Arthur Rothstein:
Words and Pictures

Arthur Rothstein

AMPHOTO
American Photographic Book Publishing Co., Inc.
New York, New York

Note: All the material in the *Words* portion of this book was previously published or presented in lecture form. See the credit at the end of each chapter.

All photographs by the author.

Library of Congress Cataloging in Publication Data

Rothstein, Arthur.
 Arthur Rothstein: Words and Pictures.
 Includes index.
 1. Photography, Journalistic. 2. Photography.
I. Title.
TR820.R663 778.9'9'07 79-18980

ISBN 0-8174-2485-7 (hardbound)
ISBN 0-8174-2157-2 (softbound)

Contents

LIST OF PHOTOGRAPHS

1
Photography—The Universal Language

Photography is truly the world's most powerful universal language for transcending all boundaries of race, politics, and nationality.

Our need to communicate with the rest of the world has never been greater, and photographs offer one of the most effective means of communication. Early in this century, several universal languages, such s Esperanto, Ido, and Interlingua were developed. But none of these equals the photograph in its simple, direct, and easily understood impact.

Under the direction of a skilled photographer, the visual image may be used to draw comparisons, to distort or emphasize, and to document social conditions. The photograph not only presents facts, it also registers ideas and emotions. Moreover, it can present events with greater accuracy than man's vision.

Powerful photographic images are fixed in the mind more readily than words, because the photograph needs no interpreter. It means the same thing all over the world. No translator is required for a picture of a soldier dying in Indochina, a refugee in the Bay of Bengal cyclone, a monk burning himself on a street in Saigon, an assassin striking at the premier of Japan, or a man walking on the moon.

Just as the writer uses words, sentences, and paragraphs to express ideas and communicate information, the photographer also assembles images. The single still picture may be expanded into a sequence—a series of highlights of chronological action—which may in turn be combined with related photographs to produce a picture story or photo essay.

The international significance of the still photograph is strengthened by its ease and economy of transmission from one part of the world to another. There are no restrictions on the distribution and movement of pictures by courier, mail, cable, or radio. In fact, a cooperative network of agencies and syndicates provides such excellent facilities that a still picture made anywhere in the world may be transmitted to any other area within an hour. In the near future, our expanding communication technology—including space satellites—may increase the speed and breadth of still pictures even more.

Unfortunately, this cooperation does not apply to the photographer. Many governments and agencies are well aware of the power of the photograph, but are reluctant to provide true freedom for the cameraman. Even in the United States, there are places where a photographer cannot operate, such as courtrooms, although word reporters are welcome.

The skilled photographer selects the significant moment. His pictures have the quality of truth and credibility; they may inform, enlighten, convince, and persuade. Therefore, the photographer who uses this universal language has a great social responsibility. His success will depend on how well he penetrates and probes the problems of our times and communicates ideas, facts, opinions, and emotions with inspirational vision.

This article appeared in *Famous Photographers Magazine*, Vol. IV, No. 15, 1971.

2
The Documentary Tradition

The documentary tradition dates back to the caveman drawing pictures on a rock. It has been perpetuated in the bas-reliefs on Egyptian tombs, in Japanese woodblock prints, on Greek vases, and in Dutch and Flemish paintings made hundreds of years ago. The lithographs of Daumier and the landscapes of William Henry Jackson were documentaries.

The documentary photographer of today is a realist rather than a romanticist. The romantics and realists have been divided since the beginning of history, and this division in artistic expression has existed as well in music, literature, and painting.

More than a hundred years ago, Mathew B. Brady was photographing the American Civil War in a realistic manner. About the same time, Oscar Rejlander made a famous photograph titled "The Two Ways of Life." It resulted from the combination printing of more than 30 negatives and showed, as an allegory, the choices facing two young men: either religion, charity, and industry; or gambling, liquor, and sex. This romantic photograph impressed Queen Vic-

toria so much that she bought the print. There is a place for each type of photography, but the realist believes that life is so exciting, it needs no further embellishment.

The difference between the documentary photographer and the illustrator of fantasy is that the documentary worker loves life and accepts his environment rather than being an escapist who is concerned with life's cosmetics. He finds it satisfying and worthwhile to use the camera to immortalize the commonplace lives of ordinary people. This work also demands high standards and responsibilities: It requires the best of a photographer's ability to see, to understand, and to interpret by selection. The means of perception is the eye, but the guide for selection is intellect and emotion. That is why the best documentary photographs are more than a record or a snapshot. The photographer is aware of his moral burden as an interpreter. Just as the written word influences the course of society, so does the straightforward, realistic, documentary photograph elicit a reaction from the general public.

Photography is well-suited to this aesthetic approach because the camera has always been invested with credibility. For the documentary photographer, simple honesty enhances the picture with the dignity of fact. Insight and emotional feeling give the integrity of truth to that fraction of a second's exposure. This is not a denial of those aesthetic elements that are essential to any work of art; but it does give limitation and direction. For example, composition may become the emphasis; and all the devices used to obtain quality—sharpness, focus, filtering, perspective,

lighting—are made to serve an end, which is to immortalize the ever-dying, ever-reborn present.

In documentary photography, every phase of our time, along with its people and their environment, has vital significance. It is necessary to know enough about the subject to find its significance in relation to its surroundings. Although Brady and Atget were of the profession, they had never heard of the term "documentary photographer." It was first used by a group of independent filmmakers who rebelled against the typical Hollywood product of the thirties. They created films that used *real* people as actors in *real* situations with *real* problems. Producers such as John Grierson, Paul Rotha, Robert Flaherty, and Pare Lorentz made dramas from our daily lives and cinematic poetry from our problems.

An important element of the documentary photograph is the fact that it usually needs words to make its image effective. Thus, many documentary photographs include signs, graffiti, or billboards. In some cases, the words of the subject are added at the time of photography. Thus, the documentary photograph is a true blend of words and pictures in which the photographs stand independently to carry the message.

Documentary describes a styl. There have been many substitutes suggested—realistic, factual, historical—but none of these conveys the deep respect for the truth and the desire to create active interpretations of the world in which we live that is the documentary tradition.

This article appeared in *The Photographic Journal of The Royal Photographic Society,* Vol. III, No. 2, February 1971.

3
An Interview for the Archives of American Art

AR—Arthur Rothstein
RD—Richard Doud

RD: *How did you first develop an interest in picture-taking?*
AR: The fact is that I went to Columbia University. But during high school, I was very interested in photography as a hobby. I had my own darkroom in the basement of my home, and I experimented with various techniques. My photographs were exhibited in pictorial salons, even as a teenager—it was a very consuming interest for me. When I went to Columbia, I founded the Columbia University Camera Club and became very active in photography as an amateur endeavor. I was responsible for inviting Mr. Steichen there to give a talk. I also used photography as a means of supplementing my tuition, by making photo-

graphs for students' theses and dissertations, and by using photography in publications. I was a member of the *Jester* staff. I was also the photographic editor of the annual *Columbian.* During that time, I had intended to go to medical school; however, the Depression came along and it didn't look as though it would be possible—tuition was very high and financial problems came up. I didn't quite know what I was going to do during my senior year. I met Roy Stryker and Rex Tugwell, who had an interesting photographic project that they wanted me to operate for them—a project involving the pictorial history of American agriculture. I commanded a small task force of students under the auspices of the National Youth Administration; and we assembled lots of photographs, which I copied with my Leica, made prints of, and then turned over to Roy. Roy deposited

them in a file cabinet for future use in a book that he and Tugwell were planning to produce, but never did.

During my senior year, Tugwell started becoming very active as one of the New Deal professors (the original Brain Trust), and he became the Resettlement Administrator. He invited Roy to come down to Washington and make a history of the Resettlement Administration (later renamed the Farm Security Administration). Because he was visually oriented, Roy decided that the best way to show the accomplishments of the FSA would be visually. He was a firm believer in the power of pictures. He felt that the best way to record and explain something was through the use of photographs. Roy was not a photographer, but he knew a lot about photographs and believed that the content and subject matter of the photograph should have meaning. So, he offered me a job as a photographer for the FSA. I jumped at the chance, and found photography so fascinating that I wanted to continue with it.

RD: *You were the first photographer hired for the FSA. What were you told you would be doing?*

AR: To me it was a great educational experience. I was a provincial New Yorker. Not only had I been born in New York City, but I even went to college there. It was a wonderful opportunity to be able to travel around the country and see what the rest of the United States was like. Also, there was a feeling of great excitement in Washington in those days—a feeling that you were in on something new and exciting; there was a missionary sense of dedication to this project—of making the world a better place in which to live.

At the very beginning, Roy Stryker had some pretty definite ideas as to what he wanted. He was tremendously interested in rural America, and he operated the photograph section more like a seminar in an educational institution than a government agency. Roy made everyone who worked with him, including me, read a great deal. We were constantly given new books that he felt were applicable to our work. We had long discussions—sometimes until one or two o'clock in the morning.

Roy loved to phone people at night. He was a great catalyst and a great stimulator, and he made people think about their work. As far as photography was concerned, Roy was not very concerned with the actual techniques. In the beginning, he left a good deal of it up to me. I ordered equipment, helped design the photographic laboratory, and worked with the photo lab people. Russell Lee was also a great technician, and he and I did a great deal of work on the actual mechanics of photography.

Roy also benefited a great deal from knowing two people already in the government who were tremendously interested in photography and in Roy's work: Ben Shahn and Walker Evans. Both of them contributed a great deal to my own development as a photographer in those days, because they had very different approaches; it was not just a question of making a picture, but making a picture that had meaning. They made me very much aware of the elements that go into photography—those that go beyond just the content of the picture—the elements of style, of individual approach, of being able to see clearly, and being able to visualize ideas. I'm quite sure that these two people did more for my development as a photographer at that particular stage than any two photographers I can think of.

Of course, I would imagine that as I've progressed in my career, there have been many people who have influenced me; certainly now (1964) I'm involved in an entirely different kind of work—photojournalism. Shahn and Evans were interested in photography as a fine art, and were not at all concerned with photojournalism.

RD: *Could you tell me how they selected the photographers who were to do the work for that project? Was there any sort of a screening process?*

AR: Not really, it just sort of happened. There were some people who were already there. When I arrived, another organization was being attached to the FSA, an organization called the Suburban Resettlement Administration. This group already had a photographer working for them, named Carl Mydans. So Mydans became one of our group. Ben Shahn and Walker Evans were there, doing things on a freelance or odd-job basis. Ben was more interested in assembling photographs that could be used as notes for his paintings. Dorothea Lange had been working for the State of California on related matters—migrant projects, and so forth. She became attached to Roy's organization in an attempt to consolidate all of her photographic activities. Then, John Vachon became a photographer. He was a file clerk who was interested in photography. I took Vachon out on his first photographic assignment and he developed into a photographer with a very definite approach and a style of his own. Theodore Jung, who had been originally hired as an artist, also wanted to try his hand at photography.

Roy was willing to let anyone take pictures who so desired. He'd let them borrow a camera, and the lab would process their film. If they became interested enough in photography to work at it, and if they did a good job, he was delighted. Marion Post, for example, came down to Washington. She had a sister who lived there, and she had been a photographer on one of the Philadelphia newspapers.

RD: *Do you remember what your first real field assignment was? It must have been sort of a "great unknown" to you. What did you do to get ready for it?*

AR: Well, there were great adventures, of course, in being a provincial New Yorker, because everything seemed fresh and exciting. The first assignment, if I remember correctly, was in the Blue Ridge Mountains of Virginia. A group of people were being moved out to make way for the Shenandoah National Park; the people lived in the hills and the hollows of the Blue Ridge Mountains not far from Washington. I went out there and stayed in a cabin on top of a mountain for a few weeks; I walked around and became acquainted with the people. At the beginning, they were very shy about having their pictures taken, but I would carry my camera along and make no attempt to take pic-

tures. Finally, they got to know me, and they didn't mind if I photographed them.

I took quite a few unusual pictures at that time, using a Leica camera and a technique that has now become almost standard. I called it the "unobtrusive camera"—the idea of becoming a part of the people's environment to such an extent that they're not even aware that pictures are being taken. I didn't do it deliberately or consciously, but out of necessity; it was the only way I could get the pictures.

The purpose of the project was to photograph the people who were going to be moved out of the area in such a way as to show some idea of how they lived and what they did, because their entire way of life was going to be destroyed. Some of the pictures I made were considered fine examples of photography. But before I set out, I had long discussions with Roy Stryker about what I was going to do and what I was going to show. Roy was the one who made me aware that there is a great deal of significance in small details. He made me aware that it was important, say, to photograph the corner of a cabin showing an old shoe and a bag of flour; or to get a close-up of a man's face; or to show a window stuffed with rags.

I just went out and photographed. I enjoyed doing it, and in the process, I developed a certain sense of design, order, and composition. I applied my early training and pictorial approaches to photography—the rules of composition—and combined that with the use of a miniature camera, which at that time was only about 6 or 7 years old.

RD: *The job you were doing for the FSA seems to have been ideal. But isn't it true that later on, many of the projects you people undertook did not deal specifically with what the FSA was doing, but with a way of life?*

AR: Roy became more and more fascinated with making a pictorial record of life in the United States. He wasn't just satisfied with the FSA, but wanted to photograph everything in the country, all details, anything significant, and some things that were of no significance. He edited a lot of the pictures, and many were not put in the files.

In the Library of Congress, you'll find strips of 35 mm film with holes punched in the middle of them—occasional negatives that Roy didn't think were suitable for the files and were not printed for one reason or another. Maybe they were duplicates, maybe they weren't the best; but Roy was a very selective person. He was indiscriminate and selective at the same time.

RD: *What puzzles me is how he could work in a government agency and so far afield from the specifications of the particular job he was supposed to do.*

AR: He had very good support from Tugwell, who was a powerful man in the Administration; and, because of his support, Roy was able to do a great many things that other people couldn't do. Also, Roy's personality was such that he was able to cut his way through all the red tape that existed in the government. He refused to become part of the bureaucracy; as a result, he was able to get a lot of things done. It's a tribute to the force of the man that he was able to accomplish all that he did.

RD: *Would you care to say something about some of your more memorable assignments?*

AR: There was one I shall always remember. It was the one that resulted in my making the famous "Dust Storm" photograph, which has probably been reproduced more than any other picture in the files. It's a photograph that I'm very proud to have made, even at this date. And when you realize that I made it in 1936, and it still holds up—to me that's an interesting commentary on the success of some photographs.

This was an assignment that had been given to me by Roy—to go to the Dust Bowl—to Oklahoma, Kansas, Texas—to those areas that were being devastated by drought and were suffering from wind erosion. It was a dramatic catastrophe in American agriculture. Strangely enough, it was a very difficult thing to show in pictures. I lived in the Dust Bowl for several months and went out every day and took pictures.

One day, while wandering through Cimarron County, Oklahoma—the panhandle of that state—I photographed a farm and the people who lived there. The farmer and his two little boys were walking past a shed on their property, and I took a photograph of them with the dust swirling all around. I had no idea at the time that it was going to become a famous photograph, but it looked like a good picture to me and I took it. It was a picture that had a very simple kind of composition, but there was something about the swirling dust and the shed behind the farmer. What it did was the kind of thing Roy always talked about—it showed an individual in relation to his environment. Of course, it's the sort of thing that painters from time immemorial have been trying to do. You know the old axiom, "Art is the expression of man." Well, if this is art, it's because it's an expression of man.

RD: *Would you discuss another picture you took, which caused as much controversy as this picture won acclaim—the "skull" photograph?*

AR: Oh, yes. The "skull" photograph did not cause controversy because of the nature of the picture, but because of the way in which it was used. The "Dust Storm" never created controversy; it helped initiate a lot of soil-conservation practices and provided legislation to remedy the existing conditions. So the picture was not controversial; it was informative. In the beginning, it was a record, after which it became a news picture. Then it became a feature photograph, eventually an historical photograph, and now it's considered a work of art in most museums. It has a life of its own.

On the other hand, I thought the "skull" picture was good when I made it. I was really resorting to some exercises in photography. One day I found myself in South Dakota standing on cracked earth where a skull lay. The texture of the skull; the texture of the earth; the cracks in the soil; the lighting, with its changes from east to west as

the sun went down, intrigued me. I spent a good part of the day taking pictures of it—experimenting—near a piece of cactus, on grass, etc.

I sent all the pictures to Washington. Roy always permitted picture editors from the Associated Press and other agencies to go through the file, and if they saw anything they liked, they could take it and print it. Without my knowledge, and perhaps even without Roy's, Max Hill, a picture editor with the Associated Press, extracted this photograph. Since he knew nothing about the West, to him it was a symbol of the drought. However, the picture was made in the month of May, and the arroyos can be found in any part of the West. The fact that you can find skulls of steers, cows, jackasses, and rabbits all over the plains meant nothing to him. He just liked the picture, probably because I lavished so much photographic artistry on it. And so he sent it out as an example of the drought.

Around June and July of that year, the drought became serious. Probably nothing would have happened if the editor of the *Fargo Forum* had not picked up the picture and said, "Now this is a real example of fakery." He didn't know that: (1) I had made the picture in May, (2) there was a caption on it that I hadn't contributed, and (3) it was sent out by the Associated Press, not by the government! As far as he was concerned, it was a government picture that was a fake—propaganda.

And the *Forum*, like most of the newspapers of the time, was opposed to the Democratic Party and the New Deal. Just as Roosevelt was going through Bismarck, North Dakota, Hill printed a special edition of the *Fargo Forum*. The picture was on the front page, labeled as a fake, and the paper was put on the train for all the news correspondents to read.

It just happened that I was in Bismarck at the time. One of the correspondents asked me if I had made the picture, and I admitted that I had. So he immediately sent a message back to Washington and got someone to dig through the files. They found a lot of other pictures that I had made, and this of course became a great joke. Cartoonists drew pictures of me wandering around the United States with a skull, planting it here and there. But the fact is that this was the furthest thing from my mind. In the first place, I didn't take the picture as an example of New Deal propaganda; I photographed something that existed and may even exist today. Although it depicted dried earth and a skull, the picture was not made with the intention of it being used as a *symbol* of the drought. Things snowballed to the point that columns were written, stories appeared in *Time* magazine, and Westbrook Pegler wrote a humorous little satirical piece about it. Some people came to the defense of the picture, and others attacked it.

RD: *Isn't it true that most pictures are fairly neutral statements, but it's how they're used, or their captions, that make them either pro or con?*

AR: Yes, that's the power of the picture—the great importance of the whole field of photojournalism. Because he has a great deal of responsibility to the people, it's important for a photographer to be reputable and to make pictures that are honest and truthful.

RD: *What other qualifications do you think that the six or eight of you representing the FSA had in common, other than an honesty toward photography?*

AR: I think we had a great social responsibility. We were dedicated to the idea that our lives can be improved; that man is the master of his environment; and that it's possible for us to live a better life, not only materially, but spiritually as well. We were all tremendously socially conscious. This quality was evident in everyone involved in the project.

RD: *What do you feel is the real value of these photographs now?*

AR: I think that they have many values: First of all, as a historical record of the times, they show how people lived on the farms and in small towns at that particular time in our life. Secondly, I think they contributed a great deal to new ideas in expressing thoughts visually through photographs. Many new techniques of visual communication were pioneered then. And the pictures also prompted a recognition of the photograph as an art form. This particular project made it quite clear to everyone that photographs have the same value and artistic qualities as good drawings, paintings, and pieces of sculpture; and that photographs can be examples of fine art.

RD: *There's a good deal of interest in the problem of poverty in Appalachia, and people have now begun to take a good many pictures of depressed areas in Pennsylvania, West Virginia, and so on. Somehow, these pictures do not touch me the way the pictures do that were taken 25 or 30 years ago by you people.*

AR: I think you should never go back. There wouldn't be much point, for example, in my trying to make photographs the way Julia Margaret Cameron did. It would be foolish to go out and try to make landscapes the way William Henry Jackson did. I don't want to go back and take pictures as I did 30 years ago. I want to take pictures the way things are today, using modern techniques, approaches, and a contemporary point of view. If you're able to say, "I've seen that somewhere before," then it loses its value.

On the other hand, suppose a photographer went to Appalachia with the intention of using modern techniques of photojournalism; e.g., trying to convey emotions through photographs, or using available light and color— not color for a picturesque quality, but color in a monochromatic sense, where the values that exist in a scene are heightened. If the photographer used these guidelines and came up with a set of pictures, you wouldn't say, "These look like the same pictures that were made by the Farm Security Administration 30 years ago." You'd say, "Here's an exciting set of pictures that gets an idea across." And that, I think, is the difference between photographs then and now.

RD: *Would you comment on what you think were some of the shortcomings of the Farm Security project?*

AR: As a matter of fact, we had long discussions about that;

we were great believers in constructive criticism. There were many things wrong; many personalities clashed and some of them still do today. But by and large, it worked, and that was the important thing. We had a good laboratory for processing films; we had excellent printers. If some of the prints weren't washed sufficiently, and they've faded today, well, that's one of the shortcomings. But who knew at that time? If in editing the pictures, Roy Stryker did not include some that perhaps today might be considered great masterpieces, I wouldn't know. Maybe his judgment was right at the time; maybe he overlooked pictures that were good. In any case, somebody had to make decisions, and as the leader of the project, Roy did. I think that we were given remarkable support by the government. Though there were a lot of petty annoyances, most of the time things went very well.

One thing that might have improved organization and productivity would have been the use of writer-photographer teams rather than individuals. A great deal more work would have been accomplished by having two people go out—one to record in words and the other to record in pictures—as reinforcement for each other. A lot of pictures in the files have very scanty captions that are not indicative of everything that took place. To write the captions, the photographer had to go through stacks of pictures, along with his notes, trying to reconstruct things. A great deal of Dorothea Lange's work is much more effective because she took her husband, Paul Taylor—a top-notch reporter—along on most of her trips. Then, there was always the problem of stirring up Congress because the pic-tures were being used. The newspapers resented the idea of the government's sending out free pictures, no matter how good they were. And the Congress was sensitive to the newspapers' displeasure. Although the pictures did get wide circulation, I think they could have been used more effectively.

RD: *If you have time, I'd like to ask for a strictly personal opinion. What is the most significant thing you learned about America and Americans? What one factor about Americans could sum up an American quality, or is there such a thing?*

AR: It's hard to answer that in terms of the way things were in the 1930s; my concept of Americans then might have been different from my concept of Americans today. Back in those days, I found that a kind of individualism existed among the people, an inability to conform, a desire to be the master of their own fate. This is a sort of trait, I think, that even to this day exists among Americans. They're not docile people; Americans don't do what you expect them to do. Each man is an individual. The one thing I found in travel-ing through the United States was that every man and every woman was different. They all came from different backgrounds and different nationalities; there was no homogeneous quality about Americans. It was a fascinating experience to learn this, and I think it still exists today, though we're losing it somewhat. With jet travel, television; newspapers all being printed pretty much the same way; and the collapse of the small town, we're becoming more and more homogeneous. So I think the one thing that im-pressed me at that time more than anything else was the great individualism of the American people.

This interview appeared in the *Archives of American Art Journal of The Smithsonian Institution,* Vol. 17, No. 1, 1977.

4
A Lecture at the Kodak Camera Club

I am very much at home in a camera club, because I helped organize one myself and am happy to say that it is still going strong. Also, I once was a frequent print exhibitor and have a large collection of mounted prints that made the rounds of the international salons.

Now I would like to acquaint you with the medium in which I work—the picture magazine. Producing a magazine requires the combined efforts of many talented, creative people; and the photographer, of course, is one of the most important.

While the artist, writer, and even the printer can trace their art back for centuries, photography has been in exis-tence a shorter time. However, during that relatively brief period, great technical and aesthetic progress has been made. We have seen the camera develop from an instru-ment that astonished people merely by the ease with which it recorded a scene, to a medium of expression that can convey ideas and emotions. There are no longer discussions about whether photography is an art. The collection of Stieglitz photographs at the Metropolitan Museum of Art in New York is as highly prized as the work of any modern painter, and it is not unusual for the Museum of Modern Art in New York to devote an entire floor to a photography exhibition. Present-day discussion is about the direction and form of the art and how we can practice it more efficiently.

Before trying to answer this, let me briefly trace for you the development of the photographic art through the years. It was in 1839 that Daguerre made his public announce-ment of a process by which anyone with some skill and practice could photograph a scene or a person. The im-

mediate effect of this was to put the portrait painter out of business, and for the next 16 years, photography was devoted to recording likenesses of people. In 1855, Roger Fenton went off to photograph the Crimean War with wet plates, and for the first time photographic coverage of history-making events was successful. This was followed by Brady's famous battlefield documents during our Civil War, which have influenced war photographers ever since.

Then along came Alfred Stieglitz, who, in 1896, started the great movement of pictorial photography with its salons, its controlled processes, and its great fight for artistic recognition. This was achieved, but Stieglitz went further, and there was little similarity between the photographs he made as a pictorialist in 1893 and those he made in 1932, except as an indication of his search for the truth and the ultimate in photographic expression.

The Photo-Secession of 1902, started by Stieglitz, emphasized the virtues of photography as an art form and removed it from the role of imitating other art. This rebellion against imitating the painter was pushed even further by Edward Steichen and Edward Weston in the 1920s.

It was during this period that the documentary photographer made a substantial contribution. The idea content of the photograph coupled with fine technique and artistic perception resulted in pictures that had a profound effect on the observer. The pioneers in this approach were Jacob Riis and Lewis Hine, and during the 1930s the Farm Security Administration (FSA) produced thousands of photographs that not only served a useful humanitarian purpose, but also synthesized the best trends in modern photography.

It was about this time, too, that newspapers began placing greater emphasis on photographic coverage; they built up larger staffs of photographers and catered to the growing visual awareness of the public by printing more and better photographs.

The arrival of the picture magazines in 1937 created an appreciative mass audience for fine photography, and it developed the picture story as an elaborate expression of ideas and emotions.

I believe that photography today owes much of its stature to the great work of the professional photojournalists on the staffs of these newspapers and magazines. It is only in this growing field of photojournalism that we find a combination of the best elements in the history of photography, as well as the incentive toward experimentation and creative thinking designed to enlarge the photographic horizon.

Those who make editorial photographs daily are inspired from the days of Daguerre to produce the faithful likeness. From the period of Fenton and Brady, we find inspiration for photographs that bear witness. Pictorialism has made us aware of the potentialities for beauty in our environment. The approach of the realistic photographers has made us conscious of good technique, honesty, and integrity. The documentary photographer has made us think of content, ideas, and emotion—the relationship of people to their environment. In the photojournalist of today, we have the synthesis of all the elements of evolution in photography.

In the study of zoology, there is an axiom that states, "Ontogeny recapitulates phylogeny," which means that the evolution of the species is recreated in the growth and development of the individual. I believe that the evolution of photography as an art form is likewise recreated in the development of each photographer as he grows to maturity.

Take me for example. I started out being fascinated by the mechanics of photography. The making of a likeness—exposure, development, printing—was satisfying in itself. It was incidental that the photographs might serve a useful purpose. I progressed to an appreciation of aesthetics, where I was devoted to composition, balance, and design. At this stage, I was a pictorialist and entered my prints in exhibitions and salons all over the world. I was more interested in producing prints that were accepted and hung for exhibition than in doing anything original. Most of my work of that period was imitative—clichés—but as long as the salons wanted them and they were accepted and exhibited, I was pleased.

The next stage in my development as a photographer was an extreme departure from pictorialism. I started doing documentary photography for the FSA and became conscious of a new concept. Photographs could be used to communicate ideas and emotions. Honesty and truthfulness in technique were important to make the pictures convincing. But technique, composition, design, and print quality were secondary to the statement the photograph made, the selection of viewpoint, the moment of exposure, and the total effect on the observer.

At this point I became aware, too, of the satisfaction of working with a functional artistic medium. I discovered that all great art has been functional; it has served some purpose other than gratification of the artist. I wanted to make photographs that had universal appeal—that were seen by a large audience—photographs that informed, entertained, or provoked.

The picture magazine was the answer, and I became a magazine photographer. Now I have a vast audience. I can use my camera to put forth any technique, any idea; and I can go anywhere in the world. My only limitation is the perception of my editors, who are only human after all, and my own inadequacies in photographic thinking. But at least freedom, opportunity, and audience are available.

You, who are camera club members, will now say, "What does this mean to me? We all can't become photojournalists." I agree, but you can learn something from them, which, I am sure, will make you better photographers.

I have gone into the history of photography and my own development as a photographer in order to point out that those of you who are addicted to pictorialism are in a state of arrested development. I use the term pictorialism to denote the practice of photography that is imitative of

paintings, lithographs, and etchings; where emphasis is on stylized formulae of design and composition, and success is based on acceptance in salons. I have gone through this educational experience and believe it helps every photographer to perform these exercises, but in my opinion it is not the pinnacle of photographic achievement.

Photography as an art form need not be imitative. There are certain characteristics inherent in the photographic process which we should all recognize and emphasize. Here they are:

- The reproduction of fine detail and texture.
- The accurate rendition or willful distortion of perspective through the proper choice of lenses.
- An infinite range of tonal values, from light to dark, which may be compressed or extended at will.
- The ability to stop motion—to capture the exact instant or the decisive moment.

These are the things that photography does best, and it does them better than any other graphic art. Those of us who do editorial photography try to get as many of these worthwhile attributes in our photographs as possible.

Another fact that we must recognize is that cameras and lenses must be selected for the job to be done. There is no universal camera. When it comes to recording detail and texture, the large view camera is superior to the 35 mm. When it is necessary to use every bit of available light, work unobtrusively, and stop action, the 35 mm camera is superior to the large view camera. The photographer who works with only one camera is beginning to realize the limitations imposed upon him by the equipment he uses. Those who are called on to cover a wide variety of assignments and are required to consistently produce photographs of the highest caliber soon begin to acquire a large number of cameras, lenses, and lighting devices.

Speaking of lighting, there are two significant trends in this field. One is the renewed use of the 35 mm camera. We are becoming more conscious of the miniature camera's potentialities for producing realistic pictures without the use of supplementary lights. The other is the refinement of electronic flash. These strobe lights are becoming lighter in weight and brighter in illumination. The tendency now is to use them as a very convenient source of general illumination. Strategically placed, three or four of them equipped with photocells will light up an area, and the photographer can work quickly without stopping to change bulbs and with a minimum of connecting wires.

Here, too, in an attempt to photograph the scene as realistically as possible, the lights are often bounced off the ceiling or walls. Sometimes the lamps in existing light fixtures are replaced with photofloods. This closely duplicates the lighting in a room, and with a miniature camera, very realistic effects are obtained.

Whenever possible, the photojournalist tries to set up equipment in advance. If this can't be don, he chooses equipment that can be quickly assembled. We are constantly striving for portability, flexibility, versatility, adaptability, and simplicity in our cameras and lights.

We realize that it is necessary to use many technical devices—lenses, cameras, and lights—to cover a job, but our main goal is to use these devices only to obtain more freedom, to make the mechanics of taking the picture as simple as possible so that we can concentrate on the subject, the idea, and the event.

In this respect it is interesting to note the tendency toward smaller cameras, lenses of wider aperture, automatic loading and winding of film, interchangeable lenses, and more accurate rangefinders and viewfinders.

These cameras will also aid the photojournalist in his approach to coverage; this means an appreciation of the need to exhaust every possibility we can find in a given situation. To us, film is the cheapest commodity we use. When something is going on that is worth capturing on film, we cover every aspect of it. It may be a series of fleeting expressions, or it may be many changes in viewpoint, angle, or elevation. Such coverage is often planned, as in the production of a picture story. It also means being ready to shoot everything that seems significant.

To project some of the trends in photography into the future, I predict that fairly soon we will have small, completely automatic cameras that will make it possible for the photographer to concentrate on the event and the subject.

I foresee a practical, simple system of color photography based on a color negative and a color positive print. We may also see a type of color print that you pull out of the back of your camera in seconds.

The high resolving power of smaller lenses, combined with extremely fine grain and fast film (perhaps based on a dye sensitivity rather than a silver-halide emulsion), will definitely cut down the size and weight of cameras. The photographer of the future may very well be pulling his camera out of his vest pocket like a piccolo player.

A system of photography based on the sensitivity of electrically chrged particles to light may soon give us a completely new concept of camera design and operation.

This is all in the future, but for the present, let me repeat some of the points I have made which we can put into practice today:

- Concentrate on the idea of your photograph and present this idea realistically.
- Use design, balance, form, and composition to enhance the presentation of your idea.
- Explore to the fullest extent the possibilities of various cameras, lenses, and lighting devices.
- Don't limit yourself to pictorialism or any other strict interpretation of photography.
- Learn to work as simply and as quickly as possible.
- Try to take pictures that serve some useful purpose.

In this way, we can all grow as individual photographers and contribute to the growth of creative photography.

This lecture was given at The Kodak Camera Club in Rochester, N.Y., on February 23, 1954.

5
My Speciality Is Versatility

To function best as a photographer, it is very important to be versatile. What do I mean by *versatile*? The dictionary defines this quality as an aptitude for new tasks or occupations, or having many-sided abilities. I would also add that the photographer who is versatile must be able to change his approach to suit the subject, remain flexible and adaptable, and have a large quantity of picture-making skills readily at command.

The versatile photographer must know all the tools of his trade. He may be compared to a composer of music, with his cameras, lenses, and lights serving as musical instruments. A successful composer knows what each instrument will do, and he employs them properly. Regardless of whether his theme is simple or complicated, he selects the instrument that most effectively makes his statement.

Most amateur and professional photographers who work effectively are versatile. Therefore, they can handle a wide variety of picture assignments or situations with confidence. In my many years of photography, the one characteristic that impresses me most is the tremendous variety of assignments that I've completed. A brief look at those I've finished in one 6-month period illustrates this.

I was first asked to photograph an animated color movie made for a big steel firm. I worked with a 35 mm camera, fast lenses, and fast film. Then came a still life of celery and celery dishes in color. The problem there was keeping the bed of ice from melting under the hot, incandescent spotlights. The solution was dry ice and rapid picture-taking so that the food did not wilt nor the ice melt.

For photographing a collection of rare antique clocks with a designer of some ultra-modern time-telling devices, I chose a Hasselblad and electronic flash. Moving to Florida for a story in color on the new bikini-style bathing suits, I again used the 35 mm and Kodachrome film. To maintain the warm color balance during cloudy periods and late in the day, I had to use filters.

Some available-light shooting came next in the Boston Garden with Wilt Chamberlain in action as the subject. I worked with two 35 mm cameras, each with a different lens and motor drive. Then came some 35 mm portraits of the president of Du Pont. The next week, in Baltimore, I photographed a model of the moon in color. Finally, I used an 8″ × 10″ camera for an on-location still life of sea scallops and seagulls on an old pier in New England with a fishing boat on the horizon.

It is necessary that most professional photographers be able to handle a wide variety of assignments such as these with flexible techniques. And being able to do so with confidence is a source of great satisfaction to them. The logical question then is how can you become a versatile photographer? I think there are some definite guideposts.

Know Your Equipment
First of all, know your equipment. Learn to handle your camera so that it becomes an integral part of your hand and eye. When you get a new camera or lens, practice with it until you know it thoroughly. Load and unload film quickly and determine the most comfortable and efficient way to hold the camera. Develop a technique that will give you steadiness for handheld shots at slow shutter speeds. I know many photographers who can make sharp pictures at very slow speeds. A good practice is to hold the camera as if it were a rifle. Standing firmly with your feet separated, support your camera with both hands, keeping your elbows in close to the body; squeeze the shutter release slowly and evenly as you would a trigger on a rifle.

Lenses
Know what the perspective and angle of view of different lenses will do to your pictures. If you are aware that a long lens flattens the perspective and pulls your subjects into a closer relationship, it may help you in planning an approach to a picture. Knowing in advance that a wide-angle lens distorts and lengthens the apparent shape of subjects is also useful knowledge.

View Cameras
Learn to work with the 4″ × 5″ and larger view cameras. Certain pictures can best be produced with this type of equipment. The rising front, adjustable back, swinging lens board, and extension bellows make possible corrections and adjustments that can often determine the success of a photo.

Light
Understand the many aspects of light. For example, train your eye and mind so that subtle changes in color and intensity of light are recognized. Study the different effects of each light variation. Bright sun, for instance, will produce brilliant color but also harsh shadows. Diffused shade lighting is better for portraits, while backlighting and sidelighting bring out form and texture.

Be able to work with daylight under all conditions: bright sun, shade, rain, fog, haze, early or late in the day. Also, be familiar with flashbulbs, electronic flash, incandescent lamps, photofloods, fluorescent lights, theater spots, and ordinary household lamps. Recognize the difference between direct and bounce light, and learn how to light a

subject with both shadows and contrast, as well as overall soft illumination.

Sensitivity to light can also be a great aid in making exposures, for it can make you independent of meters and other devices. This will give you the freedom to concentrate on the picture content. A very worthwhile game to play by yourself or with other photographers is to guess the correct exposure for a scene and then check with the exposure meter to see how accurate you are.

Filters

Have full knowledge of your filters, for they are a necessity in many situations. You must be able to predict what different filters will do. For black-and-white, a yellow K2, orange G, red A, and green XI will often help make your pictures more interesting. For color work, an 81A, yellow 81D, orange 85B, blue 82A, and blue 80B will take care of the most needed corrections. Try photographing the same scene with and without a filter, and then compare the results.

Aesthetic Expression

I am sure there is a definite relationship between a photographer's equipment and his ability to express himself aesthetically. Just as a violinist appreciates a Stradivarius, or a painter desires oils of brilliance and permanence, the versatile photographer is keenly aware of the use of sensitive, accurate emulsions; corrected, sharp lenses; easily portable and powerful lights; and well-designed, well-balanced cameras.

Style

The style of the photographer may be dictated by the nature of the camera, lens, and film he uses, as well as by the method of work which the equipment imposes. For example, the inconspicuous, handheld 35 mm camera may be used quietly, with great mobility, and under poor lighting conditions. The larger, tripod-bound view camera is slower to operate, but it makes certain corrections possible and produces transparencies and prints of higher quality.

Yet, in time, a truly versatile photographer develops a style that transcends the limitations of his equipment. The selection of significant moments and subjects is a reflection of personality and experience. The ability to choose any photographic medium becomes an aid in the creation of a strong visual statement.

Many elements enter into the development of a distinctive, personal style. It may originate with a technique, a type of lighting, a way of printing, or a strong sense of design. Look at the photographs of those who have definite style and analyze them. Try to determine the methods used and then see if you can imitate them. Imitation, in addition to being a sincere form of flattery, can also be very educational. For years, artists have learned the fine points of painting by copying the works of the masters in museums.

This article appeared in Popular Photography, November 1960.

But don't stop at copying someone else's style. Be an innovator, not an imitator, and bring out your personal tastes to help create an individual approach of your own. As the technical and creative aspects of photography improve and change, you can adapt new ideas to strengthen your style. To give just one example: The introduction of high-speed color film has made possible a type of available-light photography that reveals a whole new world of visual images.

The many-sided photographer is a craftsman and a technician who selects from several possible ways of making a picture, the one best-suited to obtaining the maximum effect. He is also able to select various approaches to composition, perspective, selective focus, and lighting. The initial confidence that comes from a knowledge of the many ways of making a photograph makes it possible for him to mentally examine and explore alternate methods before deciding on the best one.

For anyone who would like to develop a versatile approach to photography, here are some suggestions:

1. Become informed about new products, techniques, and creative ideas. Go to photographic exhibitions, read books and magazines on the subject, and make frequent visits to your camera dealer.

2. Keep in contact with other photographers and see their work. Be curious about how others get their effects, for often this will stimulate you to ideas that are an evolution or adaptation of something you have learned.

3. Experiment and explore—try different ways of doing things. Once you have perfected a given method, this becomes an important part of your background of experience to be drawn upon when needed.

4. When you discover an idea or technique that appeals to you, follow it up and make it work. Invention often leads to many applications in practice that the inventor never expected. The alert and versatile photographer is usually the first to try any new product or technique.

5. Utilize your own experience, and from this you will develop a point of view. Like a writer, the photographer should have something to say. He may be more objective because the medium is more realistic, but the most effective photographs are those that editorialize or tell a story. To produce this type of photography, you must know how to communicate a mood. This also requires a thorough knowledge of the subject, and advance preparation is always helpful. Study the area in which you will work. Plan some pictures carefully, but also be alert for the unexpected.

As a versatile photographer, you will be interested in the world about you. For when you make an exposure, it is a completion of your experience, but not one that is static or finished. Instead, you are creating another experience for the one who sees your photograph.

6
A Picture Magazine and Its Editor

I worked with Dan Mich for more than 20 years. As the editor of *Look* magazine, he gave that publication a distinctive style. He also made many fundamental and enduring contributions to the art of communicating with words and pictures.

Dan had two beliefs. First, he was continuously dissatisfied. He always believed that his magazine could be made much better with improved ideas, deeper thinking, and harder work. Second, he believed that the *Look* editorial approach should deal effectively and dramatically with the tough and controversial issues of our time. His editing angered some readers, but it won the respect of many more. One of Dan's sayings was, "Nothing we have done in the past will ever be good again." Another was, "The hottest places in hell are reserved for those who maintain their neutrality in time of moral crisis."

Dan Mich had editorial integrity. I see some publications that have lost their honesty, believability, and concern for the reader.

An editor functions for the reader, and he attempts to build an audience that will continue coming back for more. Advertising men have the job of selling that audience interest and readership to advertisers. When there is any attempt to mix those two functions, the publisher will wind up with chaos and, most probably, nothing short of disaster. It is bad business to edit with an eye on the "box office."

I am willing to admit that editors and advertising executives have one thing in common: the necessity to arouse and keep an audience interested. They each have that selling job to do. It may be a shocking realization to some editorial minds, but they must be salesmen, in a sense. If they are not successful in achieving readership of their publication, they will be looking for work. The editor's job is not only to sell the entire publication to his audience, but also to deliver each individual story and layout so that it gets maximum attention from his audience.

This brings me to another concept that Dan Mich understood so well. No matter how large a mass audience may be, it is composed of individuals. People do not receive any form of communication en masse. If you are reading a magazine or a newspaper, watching television, listening to a radio broadcast, or seeing a film, you may be part of a mass audience, but the message you receive is personal and direct—an individual matter. That is why one does not edit for, advertise for, or broadcast to, a mass. Every message, commercial or otherwise, must be directed to individuals.

Today, there seems to be a great reliance on quantitative measurement to create a composite picture of the "average" reader or listener. Every magazine learns as much about its audience as possible. Good editors know the breakdown of their readers by economic status, sex, and educational level, but they don't edit the magazine for an imaginary Mrs. Schultz in Omaha, or a composite Mr. Nelson in Minneapolis. They know that variations among individuals are too great. Dan Mich always placed great emphasis on the individual nature of a mass audience. He believed that mass communication is really communication between one person and another.

When you are communicating with another person, how can you best hold his attention? Obviously it is wise to talk about something that interests him in a manner he finds fascinating, though that is easier said than done. It is impossible for an editor to avoid offending some of his millions of readers. But he cannot shrink from realizing that controversy and vitality are two sides of the same editorial coin. Many editors today are too careful, too cautious, and too fearful about upsetting their readers. As a result, much mass communication is dull.

Advance planning, ideas, and imaginative editorial leadership can overcome this dullness. An editor must have faith in the ability and talent of his writers and photographers, and Dan Mich exhibited that quality to an exceptional degree. He backed them all the way, and they respected his judgment and decisions.

Dan was one of the pioneers in elevating the status of photographer to the same level as writer. He believed in the power of the photograph. He understood the concept of related pictures and the role of photographic talent. His book *The Technique of the Picture Story*, which was published in 1946, was a classic in its time. He believed in supporting the photographer in every possible way, particularly with the best equipment and materials. He expected and demanded first-class work.

However, good photography must be accompanied by fine writing. A few years ago, Dan gave his writers this advice at an editorial meeting:

"If I were a *Look* writer, I would stress the simple declarative sentence. I would avoid long, complicated sentences. I would never, if I could avoid it, start a sentence with a participle, a dependent clause, or a phrase. I would study the power of strong nouns and active verbs. I would minimize the use of adjectives and adverbs. I would try not to fog up my meaning by overusing words with prefixes and suffixes. I would work very hard on my leads, and try to make every lead as simple and strong as the one on this sports story. Here it is: 'Rocky Marciano's biggest victory was not scored in the ring. It was won over his manager, Al Wilde.' Two short sentences and 18 simple words, yet that lead gives the reader information, piques his curiosity, and leads him into the story with a minimum of effort.

"If I were a *Look* writer, I would not write down to the reader, but would always try to write clearly so that anyone could understand my work. Mass communication means communication to a great variety of people. It isn't hard to make yourself clear to a Harvard professor. No matter how you stumble, or how badly you express yourself, he is fairly certain to understand what you are trying to say. It is the person without education or an elastic mind who must have everything said to him clearly and succinctly. Yet, a story should never be so childish that your more sophisticated readers will be offended.

"And, if I were a *Look* writer, I would do three other things:

"First, I would surround every assignment. I would learn every fact about the subject that could be uncovered by reading and talking to people. I would try to learn ten times as much about it as would seem necessary for the space allotted. I would be prepared for a 5000-word piece, even though the space called for only 300. That way, I could be fairly sure of doing the best 300 possible. Before starting out on fieldwork or interviews, I would read every available word on the personality or situation involved and make notes on what I read. When I reached the point of asking questions, I would know what questions to ask. Instead of boring my subject with dull routine, I would be able to make the interview challenging and interesting for him. I would play the fascinating game of seeing how much I could get; and if there were one important key question that had to be answered to make the story hot, I would wear out everyone I talked to until I got it. That to me would be the fun in my job.

"Second, I would read. I would read *Huckleberry Finn* every year, plus Hemingway, F. Scott Fitzgerald, Tolstoy, John Gunther, and a hundred others. I would read every article in *Look*. I would be aware that the best writing has rhythm—a cadence—that pleases the eye as well as the ear.

"Third, I would rewrite my copy until I was positive that I couldn't make it any better. I would not want to be classified with writers who dash off their work and presume that the copy department will do the rest. I would have too much pride to turn in anything but the best piece of copy that I was capable of writing. I would rewrite again and again, and if I still were not satisfied, I would rewrite some more."

I consider this to be a superb summation of the writer's job on any publication.

For those of us who are involved in the art of communication, written and visual messages must be presented to our audience in the most effective manner; this brings me to another concept. I'm conscious of an overemphasis on the design of some publications and total disregard for it in others. In recent years we have seen disaster strike some magazines as the efforts of art directors were allowed to get in the way of the editorial message. On the other hand, we see too many newspapers of very poor design. They are made up by old-time journeyman printers, or makeup editors who know little about design, typography, and the many graphic techniques for creating readable and exciting pages.

A good art director ranks right below the editor in decision-making authority. He helps to decide how a story idea should be developed and suggests ways to give it maximum visual impact. He knows how to blend type and photographs so that each helps the other and each page comes alive to intrigue the reader. Some art directors abuse this responsibility and permit design to overpower the story, rather than assist in the telling of it. They become fascinated by shapes, forms, and patterns, forgetting their basic goal: to blend words and pictures so that the message is communicated quickly and effectively.

I see less photographic journalism being published and more photographic illustrations on the printed page. This trend can partly be explained because some art directors have become photographers, and some photographers have become more concerned with design for design's sake than with the communication of the story. Photographs are selected by art directors on the basis of their form or design rather than on the message revealed. Overemphasis on design must be avoided. Let us return to the old axiom: *form follows function*.

With all their faults, the magazines, newspapers, and broadcast facilities of this country are the best in the world. And they are better, on the average, than they were a generation ago. We need more editors like Dan Mich, who really care about the editorial qualities of their product and who are courageous enough to demand the best of their associates. We need men who stress editorial integrity; who understand the individual aspect of mass communication; and who demand meaningful, revealing photography, clear and concise writing, and effective layout. Those of you who are fortunate to find such an editor will discover how truly rewarding your work can be. Your life can be dedicated to performing a vital service with enthusiasm. You can't ask for more.

Prepared for the University of Miami Conference on Communication Arts, April 20, 1966.

7
The Amateur

It's high time photography's critics stopped condescending to amateurs. After all, amateurs discovered the photographic process and pushed it along and improved it enough to make it practical for the first professionals to enter the field.

While the term *amateur* has taken on the overtones of novice, or dabbler, it derives from the Latin *amator*, meaning lover. Thus, broadly defined, an amateur photographer is one who takes pictures for the sheer love of it rather than for the money it can generate. And this attitude has helped the medium to grow since its earliest days.

The amateur we're talking about is not the casual snapshooter who records the activities of his children, pets, family groups, and vacation trips. We mean the true amateurs with a profound and serious interest in photography. They may be students, members of a camera club, or just individuals using photography as a creative outlet and a form of self-expression.

According to recent statistics, 2.5 million nonprofessional photographers meet in 12,000 clubs in the United States. Amateur photographers buy 38 percent of all photographic products and materials, and each one, statistically speaking, owns more than $1500 worth of equipment. Some of them are restless experimenters and gadgeteers. Others are disciplined followers of rules and formulas. All of them enjoy the creative satisfaction of making, discussing, and improving photographs. This may explain why so much of the progress in photography has been a result of the efforts of amateurs.

In the beginning, the inventors of photography—Talbot, Niépce, Daguerre—were men of art and science. Soon afterwards, the amateur began to contribute to the art and technique of photography.

In 1861, all the amateur photographers in the United States formed "The American Photographic Exchange Club." Oliver Wendell Holmes was a member, and he appreciated the friendships produced by the letters and the exchange of information and photographs among the club members.

One of the most active in the club was Coleman Sellers of Philadelphia, chief engineer in a firm that manufactured machinery. His major contribution was the development of hydroelectric power at Niagara Falls. In addition, Sellers invented the kinematoscope, which was the prototype of the modern cinema projector.

Before he became a major figure in the photography world, George Eastman worked as a clerk in a bank in Rochester, N.Y. He saved his money and became interested in photography as a means of recording his travels. On one of Eastman's first trips with his wet-plate outfit, the silver-nitrate solution leaked out of the bottle and stained his clothes. This prompted Eastman to experiment with the then-new gelatin-emulsion dry plates that were described in the photographic journals of 1877.

He became so successful at producing these plates that he began to manufacture them commercially. In 1885, Eastman's company marketed what was to revolutionize photography—a roll of paper (not transparent) with a sensitive gelatin emulsion on it. It was used in a special roll-holder, from which negatives were stripped off and glass-mounted for printing. This was the prototype of roll film as we now know it. In 1888, George Eastman, an amateur image-maker, patented the roll-film camera which he named the Kodak. It was sold with the slogan, "You press the button; we do the rest." It made a fundamental change in the practice of photography.

Alfred Stieglitz, who was educated as an engineer and made a living in the photoengraving business in New York, did much to advance the art of photography. In 1891, Stieglitz joined the Society of Amateur Photographers, which merged with the New York Camera Club. He edited their publication *Camera Notes* and later published his own *Camera Work*. As a founder of the Photo-Secession in 1902, Stieglitz was a strong advocate of photography as a distinctive art form. He sponsored and encouraged other photographers, such as Paul Strand, Edward Steichen, and Clarence White. More than any other man of his era, Stieglitz raised photography to a high level of creative expression through the force of his personality and convictions.

Recently, two amateur photographers were recognized belatedly for their photographic life's work: Alice Austen and Jacques-Henri Lartigue.

Alice Austen began to take and develop her pictures in the 1880s while still in her teens. She lived in a house on Staten Island which overlooked New York harbor. For more than 60 years, she photographed her social and physical environment and the way it changed. A recent book, *Alice's World* by Ann Novotny, is illustrated with many of her photographs and tells the story of her life.

Another amateur, Jacques-Henri Lartigue also began photographing his family and friends at the start of the twentieth century. He lived an untroubled life with no financial or emotional problems, and even today, his photographs show freshness, humor, and charm. They reveal the emerging world of mechanical marvels—the train, the automobile, the airplane. Lartigue demonstrated that photography could become the folk art of the twentieth century. And today, in his 80s, still an amateur in spirit and enthusiasm, he continues to make memorable photographs.

However, twentieth-century amateurs aren't limited to

aesthetic contributions, even in a time of well-funded corporate R & D labs and technical team efforts. For example, the first color film to be successfully manufactured for general use was Kodachrome. It made its appearance on April 15, 1935, and was the invention of two amateur photographers. Leopold Godowsky and Leopold Mannes, the sons of famous musicians, who became interested in color photography when they were 16 years old. Their first experiments were conducted in the bathrooms of their parents' apartments in New York City.

Over the years, as their interest in music progressed, they continued their academic education. Godowsky took courses in physics and mathematics at UCLA, and Mannes studied physics at Harvard. The two men continued their experiments with color photography and supported themselves by working as musicians—Mannes played the piano, and Godowsky the violin. They gave lessons and appeared in concerts.

In 1930, Dr. C.E. Kenneth Mees, then in charge of research at Kodak, invited Mannes and Godowsky to work in Rochester, on the strength of their color-film experiments. In the laboratories, they accurately timed the development processes in the dark by whistling classical music!

Finally, they created a color film that a photographer could use as easily as black-and-white. Since its introduction, no other color film has enjoyed such widespread use as Kodachrome.

Even more recently, one amateur photographer revolutionized the making of pictures: Dr. Edwin H. Land of the Polaroid Corporation. It started when Dr. Land announced his invention of the instant-picture process on February 21, 1947. As a Harvard undergraduate, Land gave evidence of his genius by applying for his first patent. During World War II, he developed rangefinders, military lenses, and gunsights; and he took up photography as a hobby.

One day, while being photographed, his young daughter asked why he couldn't take the picture out of the camera after snapping the shutter. This started Dr. Land on a program of research that resulted in a camera and film that made a finished print in one minute.

In 1963, Dr. Land introduced Polacolor, and last year he announced films, cameras, and processor/projectors for Polavision, the first "instant," full-color *motion picture* process. No other person in modern times has had so much impact on photography—from snapshooting to scientific work.

These are but a few examples of the contributions of amateurs to the art and science of photography. Amateurs were also the first to illustrate books with photographs, as well as pioneering in the geographical, archaeological, and sociological applications of photography.

As a hobby, photography seems to attract particularly gifted individuals from other professions. These people, as

amateurs, are not inhibited by considerations such as the need to make a living out of photography, so they are better able to innovate.

Although amateur photography today is still vigorous, there are many influences creating confusion. Some of the attractions of image and print manipulation have disappeared, especially with the complicated color processes. Even more significant is the dearth of critical standards for photography as an art, despite its current popularity as such. As a result of modern technical and aesthetic advances, some of the old values no longer apply.

As a result, many of the present exhibitions of amateur photography and the work produced in camera clubs seem dated and old-fashioned. And this emphasis on old, worn out principles may be alienating the young people (from conventional clubs at least) who should be enjoying the hobby of photography. But, with photography's unprecedented boom, its aesthetics may change. Thousands of fine arts college students are majoring in the medium, but few can be absorbed in the ranks of the professionals. And yet their aims, their way of seeing, their commitment to photography will stay with them, presumably, throughout life. The outmoded guidelines of the past will change and merge with the new as today's students become tomorrow's true amateurs.

It is from their ranks that many of the new perceptions and techniques in the future of photography will come. A few memorable contributions from "amateur" photographers:

1834—Negative images discovered by William Henry Fox Talbot.

1839—The word "photography" coined; the use of "hypo" as a fixing agent proposed by Sir John Herschel.

1839—Daguerre's photographic process introduced.

1841—Calotype process (negative and positive images) patented by Talbot.

1842—Blueprint process introduced by Herschel.

1860—Stereoscope designed by Oliver Wendell Holmes.

1861—Kinematoscope invented by Coleman Sellers.

1864—Memorable portrait work started by Julia Margaret Cameron.

1871—Gelatin emulsion invented by Richard Leach Maddox.

1880—Sixty-year career in photography started by Alice Austen.

1884/5—First practical roll film invented by George Eastman.

1888—First Kodak camera produced by Eastman.

1902—Photo-Secession founded by Alfred Stieglitz.

1935—Kodachrome invented by Leopold Mannes and Leopold Godowsky.

1947—Polaroid instant photography invented by Edwin H. Land.

This article appeared in *Popular Photography*, February 1978.

18

8
Composition

In discussing composition, it is possible to compare the photographer's ground glass or viewfinder with the painter's canvas. Both present the problem of organizing the elements of the picture to make it most effective. But the painter has a different kind of control. If anything detracts from the strength of his statement, it can be removed. He can add something to make his meaning clear. A color in the original scene that is wrong for his interpretation can be changed.

The photographer must use other means for creating compositions. I do not start with a blank canvas. My viewfinder is always full of colored objects. One of my first considerations is selection.

Edward Weston said that composition is merely the strongest way of seeing. I would add that it is the photographer's perception and imagination that control how he views the world, and his selection of the significant that makes his composition effective.

I have read many books and articles that establish rules for composition. Most of these are attempts to transfer the formal concepts of design in painting to the photographic approach. For example, a circular design is supposed to produce a sense of unity. A triangular arrangement results in a feeling of symmetry. A strong horizontal line creates calm and tranquility. Diagonals and verticals imply action. The photographer who works only by these rules of composition will make pictures that could be done better by a painter.

I prefer to allow the subject to determine its own arrangement based on its inherent form within the framework of my selection. Once this is established, I may stress some aspects of the picture and play others down, in order to give the final composition my personal interpretation.

Thus, in my opinion, the only valid formula for composing color photographs is to perform two voluntary and deliberate actions: select and stress.

The selection of the image may be influenced by three conscious efforts.

1. The viewpoint. The camera may look up or down. It may observe from a distance or close up. Each point of view changes the composition of the picture.

2. Perspective. This is controlled by the lens. A wide-angle lens produces a different composition than a long telephoto. The relationship of the elements in the picture differs through the choice of lens.

3. The moment of exposure. This may determine the position of the subject, especially if action is involved. To stress the desirable elements in a photograph, I use three other controls.

1. Color. In the studio, light sources and filters may be used to obtain an infinite variety of effects. Outdoors, filters in front of the lens and the time of day may affect the appearance of the final picture. Color may separate the elements of the composition, isolate the subject, and indicate the center of interest.

2. Sharpness. Sometimes called selective focus, this is one of the most useful aids in composition. With it, you can blur the foreground and background, in order to concentrate on a more interesting subject in the middle. This is one of the most effective ways to place stress on the area of greatest significance.

3. Exposure. This can determine the saturation of color, which in turn, may stress the mood of the picture. It may have a high-key or low-key effect. Deliberate underexposure or overexposure will either suppress or bring out details that can contribute to a more affirmative statement.

As an example, a prize-winning color photograph of mine illustrated the wine of California. It showed a glass of champagne on a wine barrel. The top of the barrel was covered with grapes. Through the champagne glass, which acted as a lens, the reversed image of golden sky, mountains, and vineyards could be seen.

In making the photograph, I selected a viewpoint that gave me the unusual reversed image. I chose a lens for a close-up, and an exposure was used that would stop the moving bubbles in the champagne glass.

I stressed the overall green color of the vineyards to contrast with the yellow sky and champagne. Sharpness was emphasized throughout the photograph from foreground to background. I underexposed one-half stop to accent the detail in the distant sky and hills.

The importance of careful composition in color increases as the final picture gets smaller. In black-and-white photography, there is always a second chance to help the composition. During the process of enlargement, further selection of the best arrangement of elements in the picture is possible. With color transparencies, however, this becomes impractical; and with color negatives, there is a deterioration in quality. The ideal approach is to try to obtain the best composition at the time of exposure.

In color photography, more than in any other visual art, form follows content. The idea for a picture must come first, followed by a composition based on the geometry of the subject. Rather than get involved with arrangements of forms and lines, color photographers should think of composition as a means of making the picture more intelligible.

This article first appeared in *U.S. Camera*, December 1964.

9
Color Comes into Its Own

Compared to black-and-white pictures, color photographs are relatively new. (There are many black-and-white negatives and prints in existence that are more than a century old, but few color photographs are more than 50 years old.) The first color plates were put on the market in 1907 by Lumière of France, and both Alfred Stieglitz and Edward Steichen exhibited their work with the Lumière Autochrome plates in New York in November 1907. (The manufacture of Autochrome plates was stopped in 1932.)

However, since those early beginnings, color photography has expanded to the extent that today there are many more color photographs made each year than black-and-white prints. Color is the preferred medium for the amateur and snapshot photographer, and it is the choice of the commercial photographer who does advertising and portrait work. Color is also preferred by most biological, scientific, forensic, and industrial photographers and the clients for whom they work. However, it is only quite recently that serious creative photographers have started using color as a primary medium—at least partly in response to greater interest from the public.

This interest in collecting and displaying color prints as a form of art, much in the way that paintings, etchings, and drawings have long been displayed, has been given a strong boost by the recent gallery openings that are devoted exclusively to the sale of color prints.

These galleries exhibit and sell the work of many photographers, including some with established reputations. They carry color prints of varying sizes and subject matter which have been executed and processed by a number of different methods and various techniques. Prints may also be ordered from color slides, which are projected for viewing by potential customers.

There are essentially two problems—not fully resolved in some cases—that account for the "late start" color photography has encountered in its struggle to win acceptance as a form of collectible art for people to purchase and display in homes and commercial establishments. One problem is purely technical; the other is a matter of aesthetics.

The technical difficulties result from questions about the stability and archival qualities of modern color materials.

Black-and-white prints and negatives that are properly processed, washed, and stored under favorable conditions can have archival permanence and will exhibit practically no deterioration over long periods of time. Thus, they may be compared to a book or an oil painting in their ability to last through the years.

Color photographs, on the other hand, do not have this degree of permanence. A notice on every package of Kodak color film states: "Since color dyes may in time change, this film will not be replaced for, or otherwise warranted against, any change in color." The manufacturer thus warns the consumer that the material will eventually change its composition with a resulting deterioration in the color image. However, there are many variables involved, and some color materials last longer than others.

Kodachrome, for example, is more stable than Ektachrome, and some of the first Kodachromes made 40 years ago are still in good condition today. Prints and transparencies fade according to the order in which their emulsions and dye images are deposited. Dye-transfer prints lose yellow as they start to fade, while Ektacolor prints lose cyan. Dye-transfer prints are more stable than Ektacolor prints, and Cibachrome reportedly has the greatest longevity—its manufacturer maintains that this product will keep for at least 30 years and perhaps longer if properly stored.

Thus, some of the differences in the stability of color materials are due to their inherent composition in manufacture, but much of the variation in longevity also comes from the methods and techniques used in storing, viewing, and protecting these color photographs.

The greatest enemies of color materials are moisture, light, and heat; therefore, ideal conditions for preserving transparencies and prints would call for keeping them in a dry, dark, and cool place. Temperatures should be below 70 F, and relative humidity should be between 25 and 50 percent. A humidity of less than 25 percent may make films brittle and could cause them to crack when handled.

Color prints or slides should not be stored in a damp basement or a warm attic, and remember that gases released by chemicals used for moth prevention or insect control may also damage the dyes in a color photograph. Many other gases are harmful: for example, those released by motor exhausts, formaldehyde, cleaning fluids, and industrial pollutions such as hydrogen sulfide and sulfur dioxide. Do not keep color photographs near old books that may contain book lice, which also attack emulsions.

Obviously, the best way to preserve color would be to seal it in a cold, lightproof, airtight container; but this of course is impractical because the beauty of color photography requires that it be on display and suitably lit or projected.

However, heat and light from display boxes and projection lamps will rapidly accelerate the fading process. For display boxes that must be kept lit continuously, it is best to use a duplicate transparency that can be discarded after deterioration of the dyes sets in.

The increased wattage of lamps used in modern slide projectors with their transfer of more heat to the slide tray

is not desirable for the preservation of original transparencies. In order to preserve color slide, it is best to dispense with the conveniences of high-wattage automatic projectors and use the lowest wattage permissible, with a good heat-absorbing glass between the lamp and the slide and a strong blower-cooling device. Also, projection time should not exceed 30 seconds.

Color prints that are on display should be mounted, framed, and protected by glass. In mounting, avoid the use of cements or boards that may give off harmful fumes. The framing helps to seal out dust, chemicals, and moisture. Protective spray-on coatings are also available from some manufacturers.

Color prints should not be placed in direct sunlight or fluorescent light, nor should they be illuminated continuously. For ideal preservation, a color print should be treated like the old masters in some European museums; that is, it should be hidden behind black curtains to be pulled aside when the viewer wants to look at the print.

At present, the technique favored by most creative color photographers is to expose their originals on Kodachrome and then make a dye-transfer print from the selected transparency.

In the dye-transfer process, separation negatives are made from the original by exposing through red, green, and blue filters. Then, using a special matrix film, three gelatin relief matrices are made, either by contact or enlargement. After developing in a tanning developer, the surplus emulsion that has not been tanned by the solution is washed away in hot water. This leaves a positive image in relief, which varies in thickness from very thin in the light parts to thicker in the shadows.

The three matrices are dyed cyan, magenta, and yellow, so the amount of dye absorbed is in direct proportion to the lights and shadows of the image. Each matrix is then brought into contact with a sheet of special transfer paper, which absorbs the dye. Exact registration of the dyed images is necessary, and the completed dye-transfer print is thus made up from the three combined dye images.

The other print processes—Ektacolor, Ektachrome, and Cibachrome—have three emulsions coated on top of one other. They contain dye couplers to produce the finished color image during development, and they may be

This article appeared in *The New York Times*, December 5, 1976.

exposed directly to color negatives or transparencies. Of these chromagenic papers, Cibachrome has the most stable dyes; its prints exhibit high resolution, sharpness, and contrast.

Of all the printing methods, the dye-transfer has the most archival quality because it is always possible to go back to the original black-and-white separation negatives to make another print after the first has faded.

The more urgent problem in color photography is one of aesthetics. Thirty years ago, Edward Weston said:

"So many photographs—and for that matter, paintings, too—are just tinted black-and-whites. The prejudice many photographers have against color photography comes from not thinking of color as form. You can say things with color that can't be said in black-and-white. Those who think that color will eventually replace black-and-white are talking nonsense. The two do not compete with each other. They are different means to different ends."

Weston's comments still seem valid today.

The photographer who works with color cannot control his medium like the painter who creates his own mind's view of the world on canvas. However, the color photographer does have a means for recording a moment's vision with details that even the most skillful artist could never produce with oils. Further, with technical progress in color photography, more controls are becoming available both in taking the picture and in making the print.

In addition, photographers and their audiences are both becoming more sophisticated in their appreciation of high-quality color photography. Brilliance, sharpness, and strong primary colors are not as impressive as the subtle, subjective approach. Still, color must be an important and revealing element of information in the final photograph.

Those who work with color photography are learning to control their medium and to appreciate its limitations as well as its potential. Their creative efforts have been used widely by interior designers and architects for decoration in corporations and institutions. Now that their validity as an art form has been established and reaffirmed with the opening of these special galleries, color photographs will become attractive to many more discriminating buyers and collectors.

10
Creative Use of Focus, Aperture, and Shutter

Modern automated cameras, which are designed to insure accurate exposure, have given photographers freedom to concentrate on their subject. But, they may also tend to inhibit a more creative approach that can result from the selective use of individual camera controls. Fortunately, many cameras have manual overrides for their automated features, which make it possible to achieve the special effects that are inherent in a camera's operation.

The basic camera controls are those that permit adjustment of focusing, aperture, and shutter speed. An understanding of how and when to use each of these controls will result in more effective and interesting interpretations of the subject.

Whether the camera has a rangefinder, ground glass, or a combination of both, familiarity with, and practice in, focusing is essential if one wants to take sharp pictures—especially at short camera-to-subject distances where even a slight error can produce an out-of-focus picture. Sometimes it is easier to make very fine adjustments on extreme close-ups by moving the camera back or forward slightly, rather than turning the lens. And when a subject is moving so fast that it is difficult to keep in focus, one can select a spot where the subject will be and focus on that; when the subject reaches that point, the picture can be taken.

The aperture of the lens controls both the exposure (amount of light) and sharpness of the picture. When the lens is closed down, it allows less light to enter the camera, but this also increases the depth of field or zone of sharpness. As the lens is opened up, the depth of field decreases. Also, when the camera is focused on a distant subject, at any given aperture, the depth of field will be greater than it is when focused on closer subjects. Many lenses have a scale engraved on the barrel, which indicates the depth of field for all combinations of aperture and focusing distances. This scale is especially useful to the photographer who is covering fast, unpredictable action when there may be no time to focus for each shot.

In order to obtain the maximum zone of sharpness, the highest f-number on the depth-of-field scale is aligned with the infinity mark on the focusing scale. For example, with a 50 mm lens, when the infinity mark on the focusing scale is aligned with $f/16$ on the depth-of-field scale, the zone of sharpness extends from 8½ feet to infinity—meaning that everything at a distance of 8½ feet or greater will be in focus with an aperture setting of $f/16$.

At the other extreme, a shallow depth of field combined with selective focusing may be used to emphasize an area or detail and thus attract attention to an important part of the picture. For example, one can focus on a foreground object, leaving the background blurred—an effect often used in portraits where it helps to make the background soft and unobtrusive. For this, the lens is opened up to a large or wide aperture in order to decrease depth of field. Another special effect may be achieved at night, when there are many lights in the background, such as a street with illuminated signs. The lens set at its maximum opening will convert these lights into interesting, abstract, out-of-focus shapes.

In combination with the lens aperture, the shutter functions as another light-controlling mechanism to provide accurate exposure of the film. In addition, it also determines how well a moving subject may be recorded sharply, without streaks or blurs. The faster the shutter speed, the greater is its ability to "stop" motion; but as the shutter speed is increased, the lens aperture must be opened up to let more light in the camera (to make up for the fact that the shutter stays open for a briefer interval). Thus, there is always a relation between the aperture setting and the shutter speed.

Besides careless focusing, another reason for unsharp pictures, even when the subject is not moving, is camera shake. Many photographers use tripods to eliminate this problem when shooting at slow speeds, but a shutter speed of 1/125 sec. is usually fast enough to insure against blur when the camera is handheld. Anything slower can cause a slight blur that may not be visible in a contact print, but is likely to show up in an enlargement.

Sometimes the photographer wants to suggest motion by deliberately creating a blur. With the camera on a tripod and the use of a slow shutter speed, a subject in motion will be blurred, but the background will still be sharp. Another approach is to "pan" the handheld camera in the direction that the subject is moving. This results in a sharp moving image against a blurred background. This technique works best when the subject is traveling along a predictable path. The panning movement should be as continuous and as smooth as the follow-through of a golf swing. At the other extreme, cameras that are equipped with shutter speeds as fast as 1/1000 sec. provide action-stopping "frozen" effects that often reveal what the eye cannot see.

In addition to the basic controls of focus, aperture, and shutter, cameras with interchangeable lenses offer further opportunities for creative techniques. A wide-angle lens, for example, may be used to produce deliberate distortion, which makes the photograph more meaningful. An example of this would be a picture of a politician with outstretched hand looming large in the foreground. Or, a telephoto lens can be used to compress objects in a picture by

"pulling in" the background. And with the camera on a tripod, a zoom lens moved through its range of focal lengths at a slow shutter speed will make an unusual multi-image picture.

There is also a variety of other materials that can be placed in front of the camera lens to achieve special effects. A piece of ordinary window screening will produce a four-pointed star on every highlight in the scene; a second piece at a cross angle will result in an eight-pointed star (small pieces of window screen may be purchased as repair kits in a hardware store). An interesting and controllable form of diffusion may be achieved by smearing Vaseline on a piece of clear glass, which is then held in front of the lens. Apply the Vaseline from the outside towards the center, leaving a clear spot in the middle for a partially sharp image.

Many devices for altering the image may also be purchased from commercial suppliers. A diffraction grating consisting of 13,000 parallel lines per inch embossed on plastic will create a color spectrum at any point source of light in the scene; or the grating may be rotated during a time exposure to produce another visual effect. A book of acetate sheets, in colors ranging from violet through blue, green, yellow, and red, is also available to provide additional creative potential.

Multiple images of a given subject can be produced with special prisms that fit over the camera lens. One produces a six-image kaleidoscope effect; others break the image up into three or five segments—concentric or parallel—and all of these may be used in combination for more complex image mixtures. Then there are diffusion filters that may be used to produce a halo effect with backlighting or a mist-like atmospheric haze.

However, photographers should be cautious about using these special effects. As pictorial stunts, they soon become boring clichés. But, when camera and image controls are used to enhance the meaning of the photograph, they are most successful.

This article appeared in *The New York Times,* August 17, 1975.

11
Exhibitions—Their Opportunities and Problems

For a photographer, an exhibition of his work is a most gratifying experience. When an invitation to exhibit my photographs comes along, I really enjoy all the work of selecting, printing, and assembling the show.

Photography exhibitions are important, I believe, and there should be more of them. Most people's experience with other people's photographs is limited to printed reproductions; but, no matter how well-made the engravings are and what printing method is used, mass reproductions never have the subtle qualities of originals.

An exhibition is not only the best way to see pictures, but for many photographers it is the only way to bring their art and vision to public attention. Except for photographic publications, the editors of most books and periodicals are reluctant to print non-commercial, non-journalistic, or experimental photography on their pages. The types of exhibitions, the places to exhibit, and the people who control them are of great concern to photographers.

There are two main types of photographic exhibits: the individual show and the "theme" show. An important, early one-man show was Walker Evans' at New York's Museum of Modern Art in 1938. The same museum had a famous thematic show in 1955; *The Family of Man,* directed by Edward Steichen.

I have contributed as a photographer to many theme shows, but I am rarely excited about them. The individual's work tends to be lost in a variety of styles and approaches. Display techniques often overwhelm the photographs. The creative efforts of the photographer are submerged by the graphic devices of the designer.

The one-man show is really the best kind of exhibition; and the retrospective show, which covers a photographer's output over many years, is the most interesting and educational.

In selecting an individual photographer's work for exhibition, it might seem that the photographer himself is best qualified to choose. But most photographers are too emotionally involved to be objective enough. Irrelevant and personal qualities become associated with photographs; sometimes a photographer thinks a picture is great because it was difficult to make.

The most informative and exciting shows are usually assembled by those trained to select and present pictures with a definite viewpoint. They may be curators of photography, museum directors, gallery owners, or individuals with access to funds and space.

These people who control the limited exhibition space for photography have a responsibility not only to their organizations but also to the public and to the creative photographer. Unfortunately, many of them seek only to

attract crowds by showing novel and sensational material, rather than photographs with intrinsic merit. The photographer—especially the young aspiring artist who needs recognition and encouragement—suffers.

John Szarkowski of the Museum of Modern Art, who has exhibited the work of many young photographers, believes in making demands on the artist. He feels that the photographer must acquire both an awareness of working in a rich tradition and a sense of responsibility to his craft. He holds that truly creative work is never safe and easy, but implies communication, with the burden of proof squarely on the photographer.

I like to see photographs with a special and personal

This article was written for *U.S. Camera,* September 1965.

point of view—products of imagination and interpretation, in which the photographer has probed beyond superficial observation.

Exhibition is like publication in one very interesting way. Putting a lrint on a museum or gallery wall implies acceptance of the work by higher authority. But many young photographers who take their art seriously are dissatisfied with the apparent values of those who control the galleries, and each new exhibit only serves to confirm their suspicions that the "establishment" is out of line with reality.

If photography is to take its rightful place with the other arts, those who choose pictures for exhibition must be more critical and imaginative, as well as understanding of those who make pictures.

12
Pointers on Portraits

Although most of the 6 billion photographs made in the United States each year are pictures of people, not all pictures of people are portraits. A portrait should accurately reveal the subject by capturing the person's living quality and character. A good portrait is a meaningful image of an individual; and since a subject may be interpreted in various ways, making a portrait affords great opportunities for creative seeing and self-expression.

More than 100 years ago, at the age of 43, Julia Margaret Cameron started to make portraits of her family and friends. Today her photographs are recognized as masterpieces, and collectors pay thousands of dollars for one of her prints. For Mrs. Cameron, as for the average camera user of today, the subjects most often photographed are family and friends. People are usually at ease and free from tension with a photographer they know, so the casual informal photograph made with little preparation and simple equipment may often be better than the contrived formal portrait. However, for successful results, some basic rules should be followed.

Camera Position
Keep the camera just below the subject's eye level. This has a tendency to give greater authority and significance to the portrait. It also minimizes the nose, emphasizes the mouth and eyes, and makes it easier for the subject to assume a variety of natural expressions. I used this to good effect when photographing Alistair Cooke. Basically, he is a rather private, shy person, belied by his television personal-

ity. I asked Mr. Cooke to stand in front of a large map of America (the subject of his television series), and this gave him the freedom to move about, talk, and gesture in response to my questions about his work.

Lens
Use a lens of longer than normal focal length, if possible. An 85–100 mm lens on a 35 mm camera will flatter the subject by flattening perspective. The nose will appear smaller in relation to eyes and mouth, and the hands will have proper proportions. If your camera does not have interchangeable lenses, then take your portraits from a distance of at least 5 feet and enlarge the center portion. (This gives a similar effect to that achieved with a long-focal-length lens.) When photographing someone with a large nose, for example, I often do both—keep my distance and use a long-focal-length lens in order to achieve a flattering and pleasing portrait. Physical details that are unattractive should not always be concealed or ignored, but neither is it desirable to emphasize them.

Background
Choose a simple background. Portraits are best when the background is unobtrusive. An uncluttered background may be achieved by photographing against a plain wall, a curtain or window shade, a dark doorway, or the open sky. Another technique to de-emphasize the background is to use the lens at its widest aperture, thus throwing the background out of focus. Recently, I photographed my son

Robert, who is a musician, for a publicity portrait. He sat in the shade of a large pine tree. With a 180 mm lens on my Hasselblad, I exposed at 1/250 sec. at $f/2.8$. I focused on his eyes, and there was sufficient depth of field for his nose and ears to appear sharp. The background, however, became a pleasant blur of pine needles, creating an appropriate setting for the portrait.

Lighting

Be aware of lighting. Avoid direct, bright sunlight, which makes people squint and brings out wrinkles and skin defects. The soft natural light from a window can be pleasing. If an artificial light is used, keep it high and at a 45-degree angle from the subject. Flash bounced off a wall or ceiling is preferable to the harsh, on-the-camera lighting effect. By making photographs outdoors on a cloudy day problems of squinting and dark shadows are eliminated and a natural-looking portrait usually results.

Position

Choose a natural, comfortable position. Allow the subject to move freely, assuming characteristic positions while sitting or standing. With modern fast films, movement may be stopped easily, so try to maintain spontaneous, natural action. Give the subject something to do. Props are also helpful when they identify with the person being photographed—they may relate to a hobby or other interest. When there is a choice of clothing, avoid complicated prints or patterns. If the photograph is one to keep, beware of extreme fads or fashions that may appear ludicrous in future years. Adjust the clothes so that jackets and skirts are properly draped, and there are no excessive wrinkles.

Because most of our informal portraits are not retouched, makeup should be applied to cover complexion defects and skin blemishes. Men should shave and have their hair trimmed before being photographed. For women, mascara and eye makeup enhance the eyes. Also remember that the subject's legs should be crossed at the ankles for a seated portrait, because when legs are crossed at the knee, they look heavier than they really are.

Composition

Compose the picture. The photographer has many options. The location may become an essential part of the picture. A worker in the factory, an executive in the office, or an athlete on the playing field may have his portrait enhanced by including as much background as possible. At the other extreme, a close-up of a person's eyes, nose, and mouth creates a different effect. For example, my portrait of entertainer Jimmy Durante concentrated on a tight close-up of his face, showing his nose, his grin, and his

raised eyebrow—the most expressive parts of his personality. But a revealing portrait of artist John Marin included his entire disorderly studio with completed and partially finished works.

Posing

Select an appropriate pose. For a conservative straightforward portrait, a full-face view is suitable, but it may also reveal large ears or unsymmetrical features. A three-quarter view is more informal, while a profile may be dramatic. When seated, ask the subject to lean forward for a relaxed appearance. With a full-length portrait, the lower the camera is, the taller the subject will appear to be.

Photographing Children

When photographing children, get down to their level. In order to capture the emotions and human interest appeal of childhood, allow children to behave naturally. Avoid pointing the camera from above, even if this means bending down or sitting on the floor. Keep the lighting and equipment simple and work fast with a small camera and high-speed film. Photograph babies after their naps and use simple toys to obtain the reactions of wonder, surprise, and delight that make the most cherished informal portraits of children. The best photographer of a child is often the mother, who is present during many moods and can capture those elusive expressions that make memorable pictures.

Expression

Strive for a natural expression that indicates the character and personality of the subject. Previous observation and knowledge of the person being photographed is valuable in this situation. Ask the subject about work, hobbies, or interests and watch for characteristic gestures and mannerisms during the conversation. Decide whether a smile or a serious expression is the best index of personality. Be prepared to shoot fast and capture the tilt of the head, the twinkle in the eyes—the expression that creates a sincere, honest, and personal portrait. In family portraits, by shooting rapidly, maintaining control, and talking fast, a record of the decisive, revealing moment will result.

The most successful informal portrait reveals something about a person and captures an individual's characteristics. Normally, it should please the subject as well as the photographer. People usually want to be seen in a photograph as they really are. In an informal situation, the subject is more likely to cooperate fully, resulting in photographs that go beyond physical appearance and portray the subject's real identity.

This article appeared in *The New York Times*, November 17, 1974.

13
The Small Ones

A general trend or movement toward small cameras and smaller film has been characteristic of the entire evolution of photography since its beginning. When Kodak introduced the pocket Instamatic camera and the 110 film cartridge on March 16, 1972, this trend was sharply accelerated. The trend toward minaturization results from the desire of many photographers to have an instrument that is lightweight, compact, reliable, and capable of producing good-quality prints, yet inexpensive to operate. Now, after almost 5 years, there is no doubt that manufacturers, processors, and photographers have accepted the 110 format, and cameras and films are beginning to approach this ideal.

In the early history of photography, it was necessary to use large cameras that produced large negatives in order to make good pictures, because contact prints were usually made from these negatives. As finer-grained films and faster bromide paper emulsions became available, the concept of making enlargements instead of contact prints became popular; and the size of the camera gradually diminished. For example, the standard camera used by news photographers for many decades was the 5″ × 7″ Graflex, but this was later replaced by the 4″ × 5″ Speed Graphic. Then, many of them switched to cameras using 120 film with its 2¼″ × 2¼″ negative size, and now almost all photojournalists are using 35 mm cameras.

It was standard 35 mm motion picture film that inspired Oskar Barnack to create the original Leica 50 years ago. It caught on and succeeded because the small 24 × 36 mm negative could be enlarged to prints of good quality. The Leica gained in popularity because it had the small size and reliability that photographers are still seeking. Since then, the 35 mm system has become the dominant force in photography, and a wide range of equipment, accessories, and materials of all kinds have been made available to suit this format.

However, as camera designers tried to meet photographers' demands for greater versatility and ease of operation, 35 mm cameras, of necessity, grew bigger, heavier, and more expensive. Today, some of the complex, sophisticated, automated, feature-laden cameras that produce a 1″ × 1½″ negative weigh more than the old Speed Graphic, which produced a 4″ × 5″ negative.

Actually, tiny negatives are not really very new. From the earliest days, there were cameras that produced small pictures. Many were designed to deceive the subject and were called detective cameras. For example, the Thompson Revolver Photographique of 1862, which was shaped like a pistol, produced a picture less than 1 inch in diameter. The Photo-Binocular of 1867 made 50 exposures 1½ inches square. In 1886, a camera was invented to be worn under a vest, which had a lens that peered through a buttonhole and made six exposures 1⅝ inches in diameter.

But all of the cameras smaller than 35 mm suffered because of their lack of standardization. The Germans and Italians used a 12 × 17 mm negative size on unperforated 16 mm film, as in the Gami. The Japanese had a 10 × 14 mm frame on single-perforated 16 mm film, as in the Minolta 16. There were also half-frame 18 × 24 mm negatives on 35 mm film, such as the Sept and the recent Olympus Pen, as well as the Tessina with a 14 × 21 mm negative size. The most famous ultraminiature, the Minox, which used an 8 × 11 mm format, was widely used as a spy camera.

With all of these miniature cameras, the absence of standards created a situation where films were expensive, difficult to obtain, and of questionable quality. Processing also became an ordeal, and color photography with most of these cameras was almost impossible.

All of this changed dramatically when Kodak introduced the pocket Instamatic with its 13 × 17 mm format. Film and processing of tiny negatives became routine, inexpensive, reliable, and available everywhere. Late in the summer of 1975, at a meeting of security analysts in Atlanta, Walter Fallon, then president of Kodak, said, "It is just the most popular camera ever made." At that time, more than 25 million had already been sold.

According to Kodak, some of the main reasons for the great success of the 110 camera are: (1) it's easy to use and portable, (2) it has simple cartridge-loading film, and (3) it produces a rectangular picture. Now, after a few years, camera design is finally beginning to catch up to this new film format.

For the average photographer, the advantages of the small negative far outweigh its disadvantages. The film is compact and lightweight. Three 20-exposure cassettes take up less room than a pack of playing cards, and the cost per exposure is low. This means that more pictures may be made of a given subject; the photographer has a better chance to capture the best expression and decisive action; and people don't hesitate to shoot as much.

"The 110 system is at the same stage in its development as the 35 mm was in 1930," says Robert Doherty, Director of the International Museum of Photography at George Eastman House in Rochester. "The quality is spectacular and the cameras are marvels of engineering. But," he cautions, "let's hope the designers remember to keep them small, compact, and simple with high-quality results so they don't become like the present 35 mm cameras."

The greatest impetus to the use of the 110 format will result from innovations in film and processing. With new, faster, fine-grain color negative film, enlarged color prints of excellent quality are already available at low cost. This is all the more remarkable when the degree of enlargement is considered. An 8″ × 10″ print made from a 35 mm negative requires an 8X blowup. A similar print from a 110 negative requires a 16X enlargement. Many custom labs routinely produce high-quality color prints in the 30″ × 40″ size from a 35 mm frame negative, so it is reasonable to expect equally good quality prints as large as 16″ × 20″ from 110 negatives.

The limiting factor may be the quality of the enlarging lens, which will have to be improved; also, the magnification of dirt may be a problem. At present, few photographers are using the 110 format professionally. But who would have thought that Super 8 could be used as a professional movie film? Years ago, such thin emulsions of high resolution didn't exist.

This article appeared in *The New York Times*, February 13, 1974.

14
Photojournalism

Photojournalism, which is taken too much for granted by both reader and viewer, hasn't been around forever—it only seems that way.

Such commonplace acceptance best illustrates the impact of the eyewitness reporter, whose camera work as we know it, is less than a century old.

The reproduction and mass distribution of photographs was sparked by two critical discoveries:

1. A practical camera negative from which positive prints could be made. This was the discovery of William Henry Fox Talbot, who first reported it to the Royal Society of London in January 1839.
2. The halftone process, which made possible the quick and cheap reproduction of a photograph in conjunction with words set in type. The first photograph to be printed in this manner was of Shantytown, a squatter's camp in New York, photographed by Henry J. Newton. It appeared in the *New York Daily Graphic* on March 4, 1880, as a result of Stephen Henry Horgan's experiments.

These two inventions are the foundation of modern visual communication. But their concept of telling the news pictorially goes back to the cave paintings of prehistoric times. Our words are composed from alphabets that were originally pictures.

Recent designs of new 110 cameras indicate imaginative direction. One model has reflex viewing and focusing, and carries a 25–50 mm zoom lens. Another has a coupled rangefinder, an f/2 lens, and a date imprinter. A popular 110 camera has a 25 mm lens that converts to 43 mm. Another recent camera features a parallax-corrected viewfinder, a rangefinder, and an electronic shutter that gives completely automatic exposure for daylight and flash—all in a compact package that weighs only 5 ounces.

"It's an ideal second camera," says an executive of Kodak. "We expect that 35 mm cameras will remain popular with serious photographers, even though there will be continued improvement in 110 film and cameras. There is room for both."

However, there is always the real possibility that the ideal second camera may become first.

The great artists, Hogarth, Goya, and Daumier were journalists too. The words "Yo lo vi" ("This I saw!") are scribbled under one of Goya's gruesome war scenes of the battle between Spanish partisans and Napoleon's troops in 1880. Certainly, the concept of picture reporting is as old as man's drive to tell a story through drawings. The use of the camera merely makes the pictorial presentation more efficient, faster, and available to more people.

Today's photojournalist is a product of a process that started in 1839 when Daguerre made public the details of his method. The use of the daguerreotype for portraiture established the medium as a superb means of creating a likeness. The portrait painter was put out of business, and the photographer took his place. An outstanding example of the early effectiveness of the photograph as an accurate record was Mathew B. Brady's portrait of Abraham Lincoln. When widely reproduced and circulated prior to the presidential election of 1860, Brady's photograph helped dispel the notion that Lincoln was a rough and uncouth backwoods character. The serious, thoughtful, and dignified appearance of Lincoln in the portrait, plus its extensive distribution, caused Lincoln to give Brady credit for helping him become president.

The camera as an accurate recording instrument, and the existence of the concept in the minds of the public has

been a fundamental factor in the development of the photo-journalist. Coupled with this is the idea of the camera and its trained observer functioning as a witness to events.

When Roger Fenton photographed the Crimean War in 1855, the long tradition of the photojournalist covering history-making events began. Fenton's pictures could not be published, although wood engravings of some of the scenes were made and printed in the *Illustrated London News*. It was impossible, with the slow, wet collodion process used, to show the action of war. But even in the dull landscapes of the battlefields, there was a sense of reality that had never existed before.

Considering the primitive methods used, the work of Mathew B. Brady in documenting the Civil War was remarkable. He and his staff produced 7000 wet-plate negatives, which, according to his catalogue, were taken on the spot during the progress of hostilities and represent war exactly as it appeared. These photographs, now in the Library of Congress, have influenced war photographers ever since. Here, for the first time, the special quality of photography became evident—the strong sense of realism and truth and the participation of the photographer at the scene as a witness.

Since Brady's time, improved photographic techniques and faster methods of transmission have made war photography more significant and the cameraman a more vulnerable witness. In order to obtain pictures with dramatic emphasis, the photographer has had to expose himself to dangers as great as, if not greater than, the combatant. In modern times, an outstanding photojournalist who carried on in the tradition of Brady was Robert Capa. Starting with the Spanish Civil War in 1935, Capa photographed the battlefields of his times for 20 years. His tragic death came when he stepped on a land mine while covering the war in Indochina. Here is the ultimate sincerity in photographic evidence, conclusively demonstrating the recurring sacrifices.

The documentary photographer made a substantial contribution to photojournalism. While all unretouched photographs are documents in the sense that they may be accepted as evidence or proof, the term documentary has been applied more specifically to photographs that not only present facts, but comment on them. The most effective documentary photographs are those that convince their observers with such compelling, persuading truth that they are moved to action. An early example was the work of William H. Jackson, who photographed the natural wonders of the West in 1870. Jackson's photographs of the Yellowstone area helped convince Congress of the importance of preserving the region for the public, and the first National Park was created.

In 1890, Jacob Riis, one of the first to use flash powder, photographed the sordid slums of New York and used these pictures to help his crusade for housing reforms. In the early 1900s, another effective commentator with the camera, Lewis W. Hine, was the first to employ the photo-story as a journalistic device. His coordinated pictures and captions on child labor, immigrants, and coal miners had a strong influence on legislation designed to correct those social injustices.

Half a century later, under the stimulation and encouragement of Roy E. Stryker, the Farm Security Administration (FSA) photographic project used the camera most extensively to help effect rural reform. From 1935 to 1942, photographs of agricultural conditions, widely reproduced in newspapers and magazines, made the public aware of the need for rural rehabilitation. In addition, the thousands of photographs now in the Library of Congress synthesized some of the best trends in modern photography and influenced the attitudes of many of today's photojournalists.

The subtle and direct use of photography, emphasizing the inherent characteristics of detail and tonal gradation were part of Edward Weston's approach. But most important for the photojournalist was his insistence on visualizing the final print before making the exposure. Although Weston used an 8″ × 10″ camera, this same straightforward technique of incorporating the utmost respect for the final image marks the work of another great contemporary photojournalist, Henri Cartier-Bresson, who uses a 35 mm camera.

Photographers have also been influenced by technical advances. They are more than 100 years beyond Mathew Brady, who coated his heavy glass plates before exposing them on the Civil War battlefield. They are 50 years ahead of Jacob Riis, who used flash powder to illuminate the slums of New York. And it was only 25 years ago that the 30-pound "Big Bertha" lens was used on a 5″ × 7″ Graflex to cover baseball and football games and political conventions.

In fact, the 35 mm camera has created a modern photojournalist phenomenon—the *paparazzi*. These are the sneak photographers who specialize in catching international celebrities off guard. The name comes from a character in Fellini's film *La Dolce Vita*—a photographer named Paparazzo, who runs around taking pictures of people in embarrassing situations. Paparazzo is close to the Italian word *pappataci*, which means gnat, an annoying, buzzing, stinging insect.

Our best known paparazzo is Ron Galella, who was sued by Jacqueline Kennedy Onassis for invading her privacy. The decision was in favor of Mrs. Onassis, but usually public figures such as politicians, actors, and other celebrities are considered fair game for photographers.

One of the most famous sneak photographs was made in 1928 when Ruth Snyder was executed in the electric chair in Sing Sing prison. The *New York Daily News* brought in Tom Howard, a photographer on the *Chicago Tribune*, who practiced with a miniature camera strapped to his ankle. Using only one glass plate, he made a 5-second exposure, recording the body movements during the execution. The front page picture on Friday, January 13th, was a sensation.

28

With all the technical tricks of the trade, the photographer still has to be where the action takes place and must react with skill and instinct. This is how great pictures are always made.

During the difficult days of fighting in the Pacific in World War II, one photograph raised the morale of the United States. An Associated Press photographer, Joe Rosenthal, landed with the Marines on Iwo Jima. He photographed the battle over the island and climbed to the top of Mount Suribachi for the victorious flag-raising after 6821 Americans were killed. It was unposed, unrehearsed, and unstaged. Rosenthal caught the scene as he said, "right at the peak of action. One tiny part of a second off, and you lose it." In 1945, he won the Pulitzer Prize for the picture that was then recreated in bronze as a monument to the nation's heroes and now stands in Washington, D.C.

Wars and their aftermath have provided photojournalists with some of the most famous pictures of all time. In 1937, Japanese planes bombed the railroad station in Shanghai, China, where 1800 refugees—mostly women and children—were waiting to be evacuated. H.S. "Newsreel" Wong photographed the tragedy, and his picture of the crying baby in the wrecked station stirred the world. The impact of the photograph and its international repercussions were such that the Japanese claimed it was a fake and they threatened Wong's life. He had to flee with his family to Hong Kong.

During the Korean War in 1950, Max Desfor of the Associated Press parachuted into North Korea and photographed the retreating United Nations forces. At Pyongyang, he recorded the amazing sight of thousands of refugees swarming across the skeleton of a bombed bridge. It vividly illustrated their will for survival as they crawled away from the Communists.

In the recent conflict in Southeast Asia, many memorable images stay in our minds. In 1963, Malcolm Browne's photograph of a Buddhist monk's self-immolation horrified the world and contributed to the collapse of the Diem government. And, in 1968, the police chief of South Vietnam, General Loan, summarily executed a Viet Cong suspect in a Saigon street. Eddie Adams photographed the action, and the people of the United States reacted in shock and revulsion. They asked, in effect, is this the kind of democracy and freedom that we are fighting for in Southeast Asia? Four years later, Nick Ut photographed a naked child fleeing from a napalm bomb attack. The horror of war, as expressed by this photograph, helped turn the tide of public opinion against United States involvement in Vietnam.

Both man-made and natural catastrophies provide photographic images that are remembered long after the event. One example is the author's photograph of the dust storm in Cimarron County, Oklahoma, in 1936. The picture of Arthur Coble and his sons, Milton and Darrel, on their ruined farm demonstrated the relationship between a natural disaster and its effect on people. Widely reproduced, it helped arouse sympathy for farmers. People across the nation began to understand why "Okies" were migrating to California and why black blizzards darkened the sky in the east.

Another disaster, the earthquake and fire that hit San Francisco in 1906, was covered by photographers from the *Call,* the *Chronicle,* and the *Examiner.* The view from Telegraph Hill by Arnold Genthe is especially dramatic. The photographs were published in a joint newspaper on the presses of the *Oakland Tribune.*

In 1937, the German dirigible *Hindenburg* was completing its thirty-seventh crossing of the Atlantic when it burst into flames as it approached its mooring in Lakehurst, N.J. Sam Shere of International News Photos made a photograph with his Speed Graphic at the peak of the explosion. Murray Becker of the Associated Press, with cool deliberation, exposed a sequence of three film holders within 5 seconds. The *New York Mirror's* Gerry Sheedy photographed it with 35 mm Kodachrome. These photographers witnessed and recorded the end of dirigible transportation.

The financial center of the United States in 1920—as it is today—was Wall Street. At noon, in front of the Sub Treasury Building, a horse-drawn wagon blew up injuring 400 people and killing 39. It was the worst explosion in New York history. The *New York Daily News* was at Park Place, and hearing the noise of the bomb, George Schmid ran to Wall Street to photograph the disaster. The case was never solved.

In terms of lives lost and property damage, the Texas City disaster of 1947 was one of the worst. As a shipment of ammonium nitrate fertilizer was being loaded onto a French vessel in the Texas port, it caught fire and exploded. More than 570 people were killed; 3000 were injured; and buildings collapsed in the city a mile away. A photographer from the *Houston Post* raced to the port and made a dramatic shot of the bodies being carried away from the burning debris. She was 22-year-old Caroline Valenta.

Women photojournalists have always made important contributions. Dickie Chappelle was killed in Southeast Asia while covering the war. Lisa Larsen worked for *Life,* and Charlotte Brooks worked for *Look.* Probably the best known was Margaret Bourke-White, whose first cover for *Life* magazine in 1936 was the construction of the Fort Peck dam in Montana. Bourke-White's assignments included coverage of World War II in Italy, the concentration camps in Germany, the population dislocation in India, and racial tension in South Africa. She said, "Everything in the picture should contribute to the statement. Good photography is a pruning process, a matter of fastidious selection."

The selection of the decisive moment shows in the many famous news photographs of assassinations, from the 1910 shooting of Mayor Gaynor in New York to the 1960 stabbing of socialist Inejiro Asanuma in Tokyo. When Jack Ruby shot Lee Harvey Oswald, in the wake of the assassination of President Kennedy, Bob Jackson of the *Dallas Times Herald* clicked his shutter as the gun went off. His picture won the Pulitzer Prize in 1964.

A special kind of editor, conscious of the power of pictures, also contributed to the development of photojournalism. One such editor was Stefan Lorant, who pioneered the concept of words and pictures in Europe, both in Germany and England. He encouraged and used the skills of many photographers including Erich Salomon, the world's first candid cameraman, who died in a Nazi concentration camp. Wilson Hicks, a picture editor with the Associated Press, became the executive editor of *Life* magazine. He assembled one of the greatest staffs of photographic talent in the history of photojournalism. Dan Mich, editor of *Look* magazine, described the basic principle of combining words and pictures in "The Technique of the Picture Story." He was among the first to recognize photographers and writers with equal consideration.

The photojournalist in the United States enjoys the most prestige. According to Dmitri Baltermants of the *Novosti* staff, the Soviet Union is 20 years behind.

Yet Bill Strode, past president of the National Press Photographers Association, says the photojournalist now suffers from a credibility problem. Readers don't believe what they see. Some claim that the press is controlled and events are staged. An army of public relations experts in government and industry contribute to this impression through their organization of the "media event."

Recently, and without any evidence, some writers of books and articles have claimed that certain historic pictures were faked. The credibility of Robert Capa's famous "Moment of Death" photograph of a Spanish Loyalist soldier is questioned. An article in a newsletter states that Joe Rosenthal's photograph of the flag-raising at Iwo Jima was "choreographed."

Designed to obtain sensational publicity for their authors, these statements are damaging to the photojournalist. They do emphasize the urgent need to promote the truth, honesty, and objectivity of camera reporting.

For many photojournalists, an area of concern is the possibility that television may replace the printed page as the prime medium of visual communication. It is certainly the best source for bulletins and live, on-the-spot coverage of important news. On the other hand, the picture on the printed page is archival, convenient, and infinitely retrievable. It may be examined as long and as often as desired. With a blend of meaningful words and skillful layout, it becomes more than a witness to an event. It can provide information, interpretation, and insight that far transcends the transitory, electronic image of television.

However, the technical devices associated with electronic communication are creating a change in the method of distributing photographs. One of the great assets of the still photograph is its rapidity of transmission. At present, a cooperative network of agencies and syndicates can transmit a picture to any part of the world within an hour, via cable, radio, and satellite.

Now with an ingenious combination of laser light and a dry-process photographic paper, the Associated Press will move its pictures worldwide with greatly improved sharpness and clarity. The use of digital rather than analog transmission lines will minimize interference. Also, it will make practical the computer storage of images. Eventually, the entire process of photojournalism may be dry, electronic, and instantaneous.

As a result of increased exposure to all forms of photography, our present generation has developed an increased sophistication and awareness of the pictorial image. Photography is closest to a universal language. Its audience demands pictures that convey information quickly and concisely. In order to communicate effectively, the photojournalist must get to the point immediately. Neither the reader's time nor the resources of paper, printing, or film can be wasted. Every picture must have value and importance.

This article appeared in *The Journal of Photography,* published by the Royal Photographic Society, March 1978.

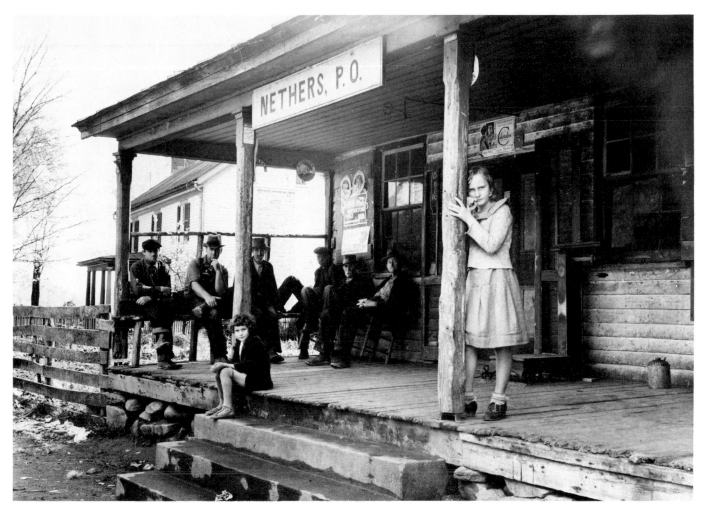

Post Office, Nethers, Virginia, 1935.
Leica D 35 mm, with Elmar 50 mm lens.
Panatomic film exposed 1/60 sec. at f/6.3.

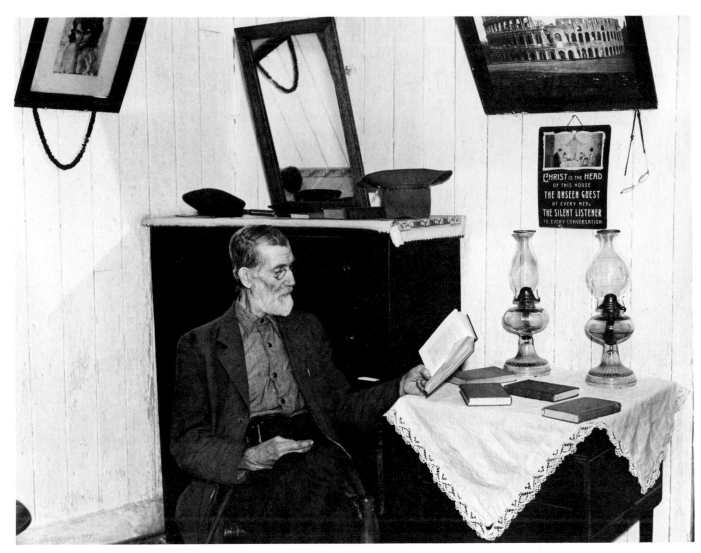

Postmaster Brown, Old Rag, Virginia, 1935.
Linhof 9 × 12 cm, with Tessar 13.5 cm lens.
Panchro Press film exposed 1/100 sec. at f/16 with a Press
40 flashbulb.

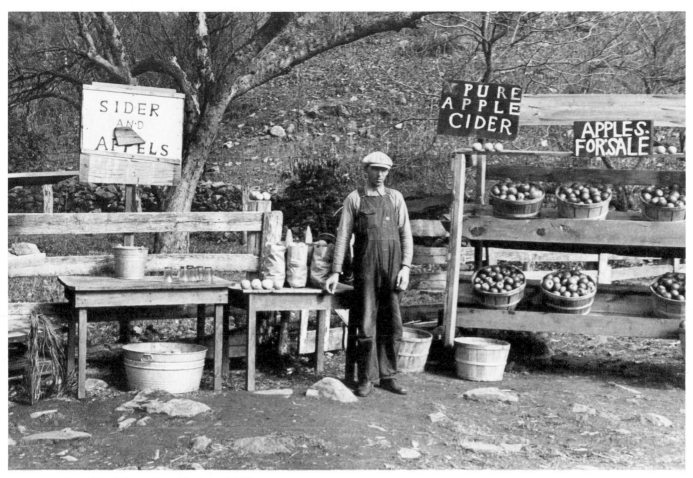

Blue Ridge Mountains, Virginia, 1935.
Leica D 35 mm, with Elmar 50 mm lens.
Panatomic film exposed 1/60 sec. at f/6.3.

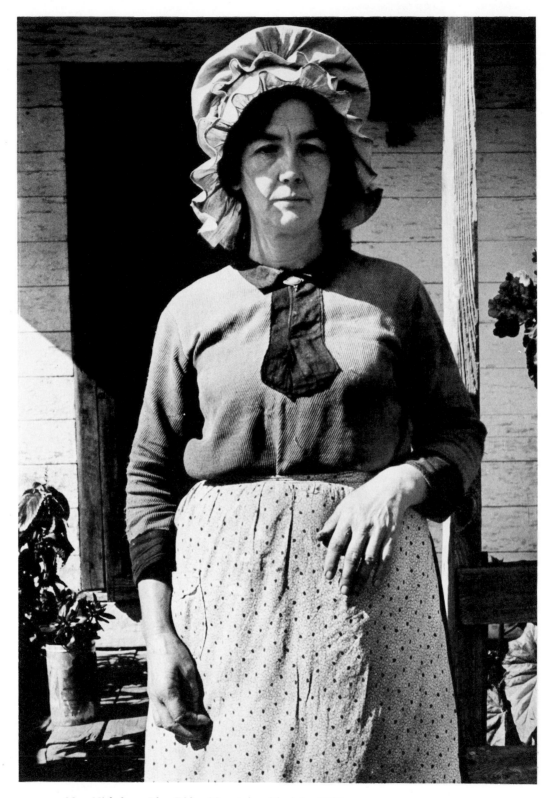

Mrs. Nicholson, Blue Ridge Mountains, Virginia, 1935.
Leica D 35 mm, with Elmar 50 mm lens.
Panatomic film exposed 1/60 sec. at f/6.3.

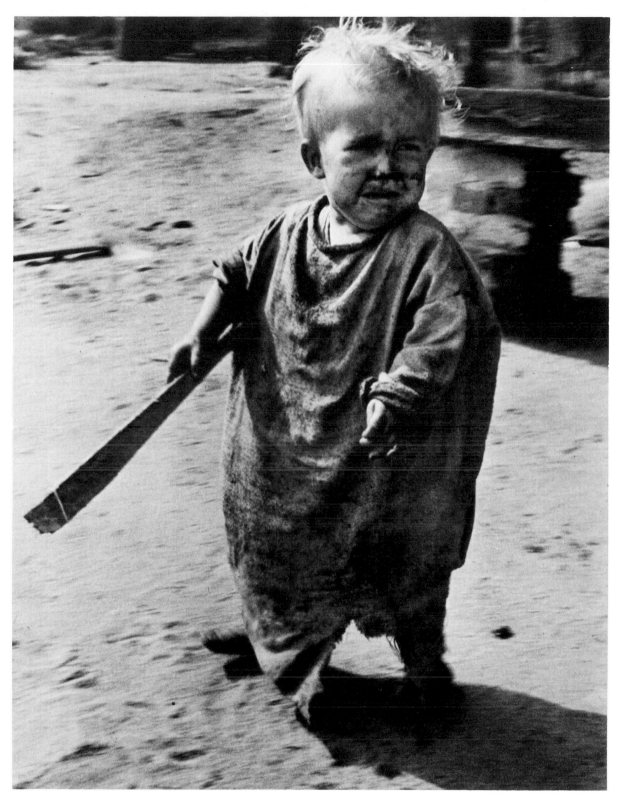

Baby in Burlap, North Carolina, 1935.
Leica D 35 mm, with Elmar 50 mm lens.
Panatomic film exposed 1/60 sec. at f/6.3.

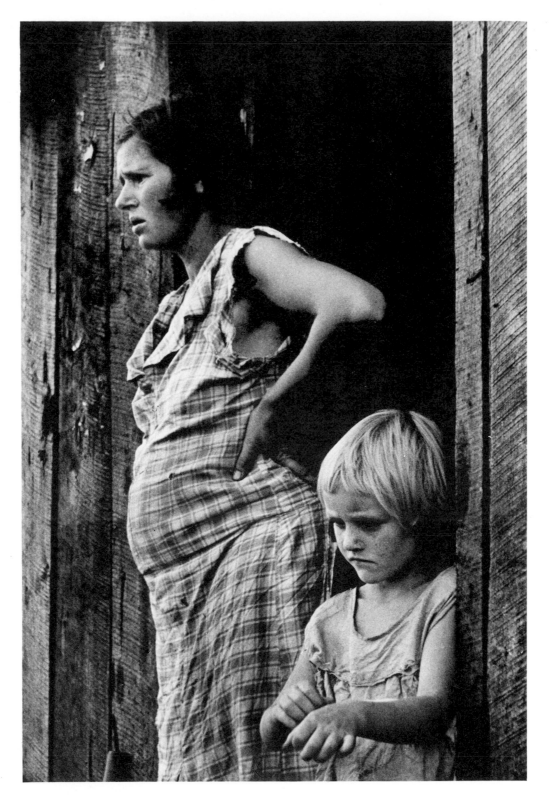

Sharecropper's Wife, Arkansas, 1935.
Leica D 35 mm, with Elmar 50 mm lens.
Panatomic film exposed 1/60 sec. at f/6.3.

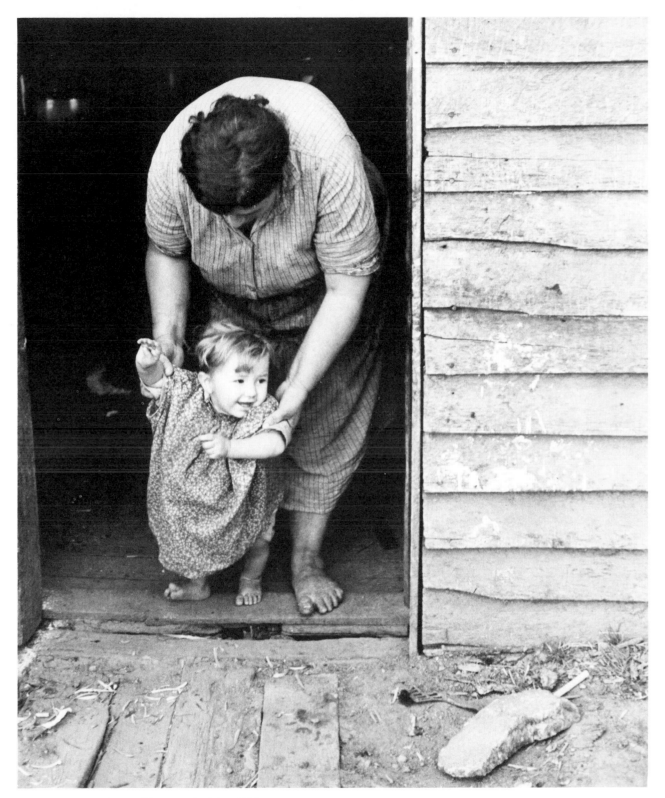

Mrs. Dodson, Old Rag, Virginia, 1935.
Leica D 35 mm, with Elmar 50 mm lens.
Panatomic film exposed 1/60 sec. at f/6.3.

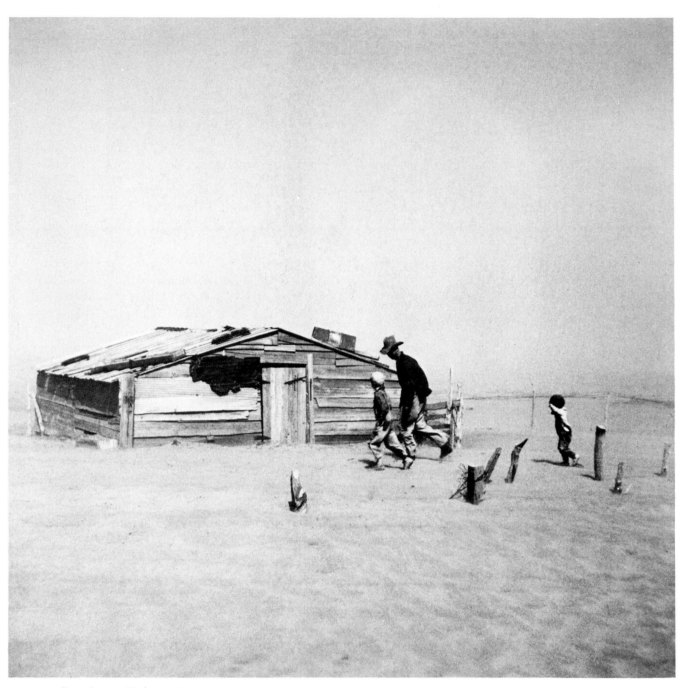

Dust Storm, Cimarron County, Oklahoma, 1936.
Super Ikonta B 6 × 6 cm, with Tessar 80 mm lens.
Panatomic film exposed 1/100 sec. at f/8.

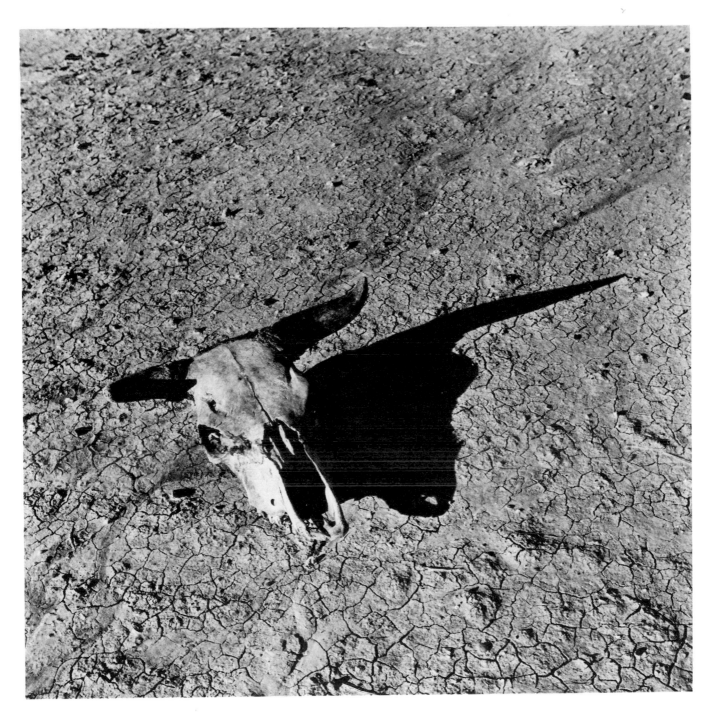

Skull, Badlands, South Dakota, 1936.
Super Ikonta B 6 × 6 cm, with Tessar 80 mm lens.
Panatomic film exposed 1/100 sec. at f/8.

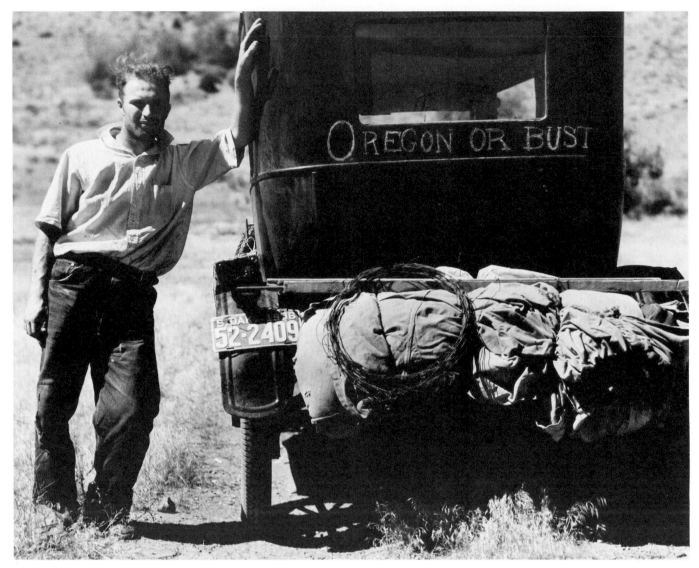

Vernon Evans, Migrant to Oregon from South Dakota,
1936.
Linhof 9 × 12 cm, with Tessar 13.5 cm lens.
Panchro Press film exposed 1/200 sec. at f/8.

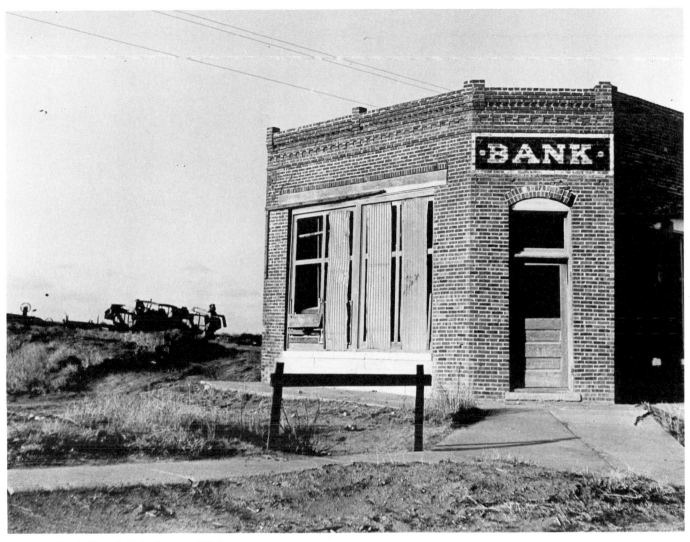

Bank That Failed, Kansas, 1936.
Super Ikonta B 6 × 6 cm, with Tessar 80 mm lens.
Panatomic film exposed 1/100 sec. at f/8.

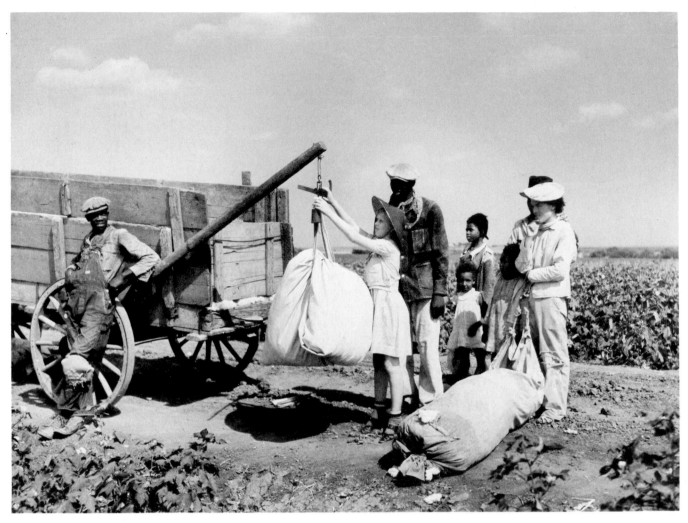

Weighing Cotton, Kaufman County, Texas, 1936.
Linhof 9 × 12 cm, with Tessar 13.5 cm lens.
Panchro Press film exposed 1/100 sec. at f/8 with a K2 filter.

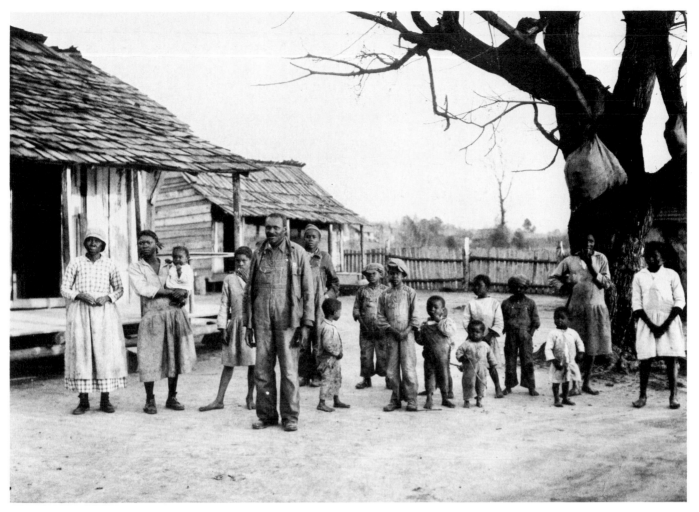

Large Family, Gee's Bend, Alabama, 1937.
Linhof 9 × 12 cm, with Tessar 13.5 cm lens.
Panchro Press film exposed 1/100 sec. at *f*/8.

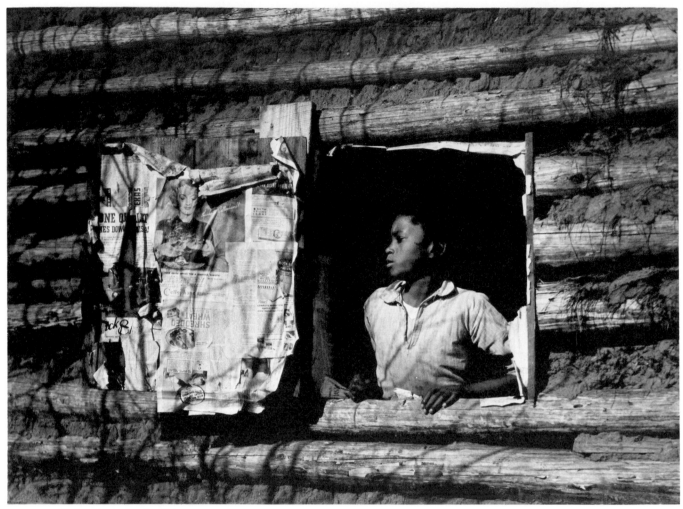

Girl at Gee's Bend, Alabama, 1937.
Linhof 9 × 12 cm, with Tessar 13.5 cm lens.
Panchro Press film exposed 1/100 sec. at f/11.

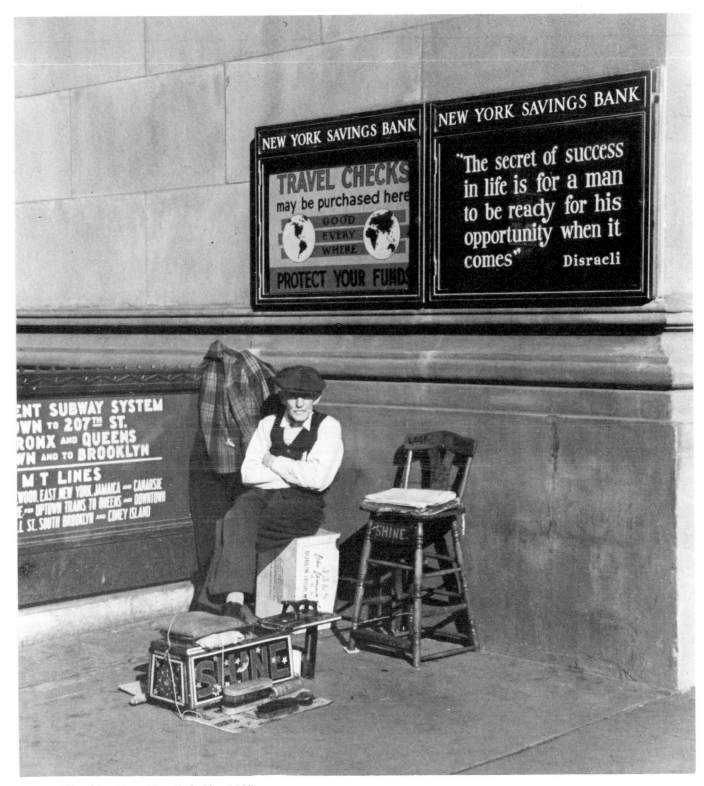

Shoeshine Man, New York City, 1937.
Leica D 35 mm, with Elmar 50 mm lens.
Panatomic film exposed 1/60 sec. at f/9.

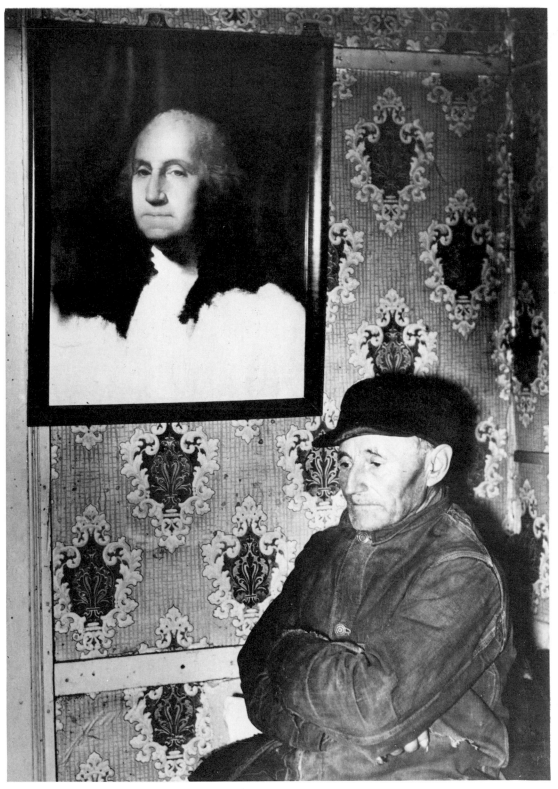

John Dudeck, Dalton, New York, 1937.
Linhof 9 × 12 cm, with Tessar 13.5 cm lens.
Panchro Press film exposed 1/100 sec. at f/16 with a Press
40 flashbulb.

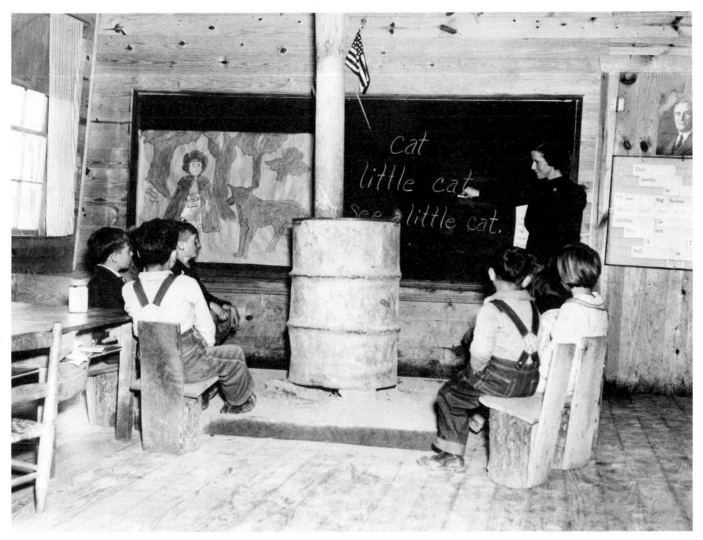

Rural School, Alabama, 1938.
Linhof 9 × 12 cm, with Tessar 13.5 cm lens.
Panchro Press film exposed 1/100 sec. at f/16 with a Press
40 flashbulb.

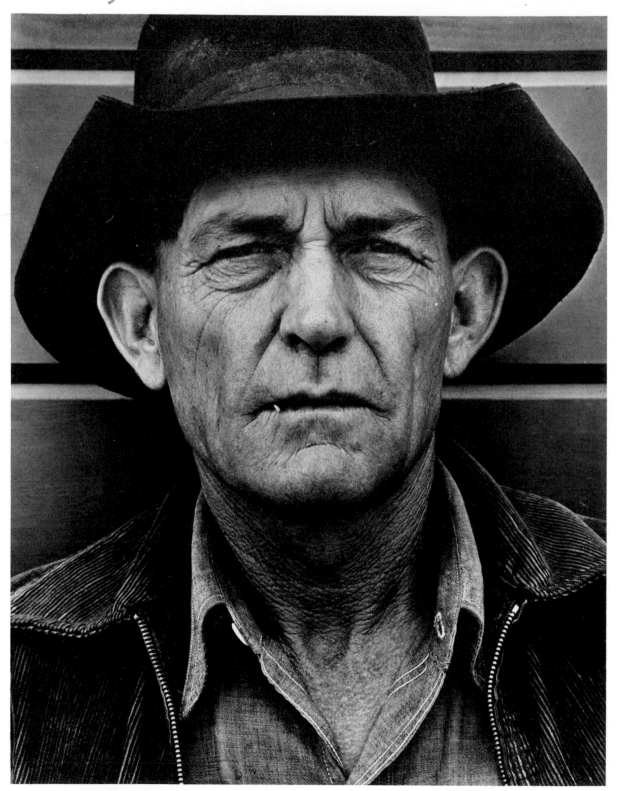

Rancher, Montana, 1939.
Linhof 9 × 12 cm, with Double Protar 15 cm lens.
Panatomic film exposed 1/100 sec. at *f*/16.

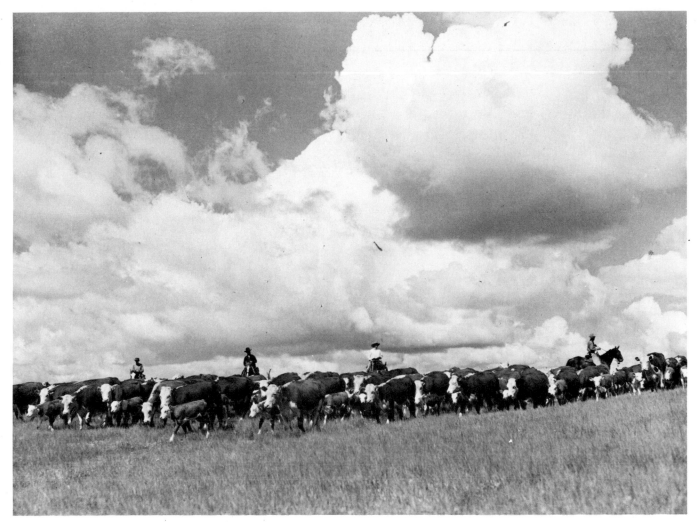

Roundup, Three Circle Ranch, Powder River, Montana,
1939.
Linhof 9 × 12 cm, with Tessar 13.5 cm lens.
Super Speed Pan film exposed 1/200 sec. at f/8 with a K2
filter.

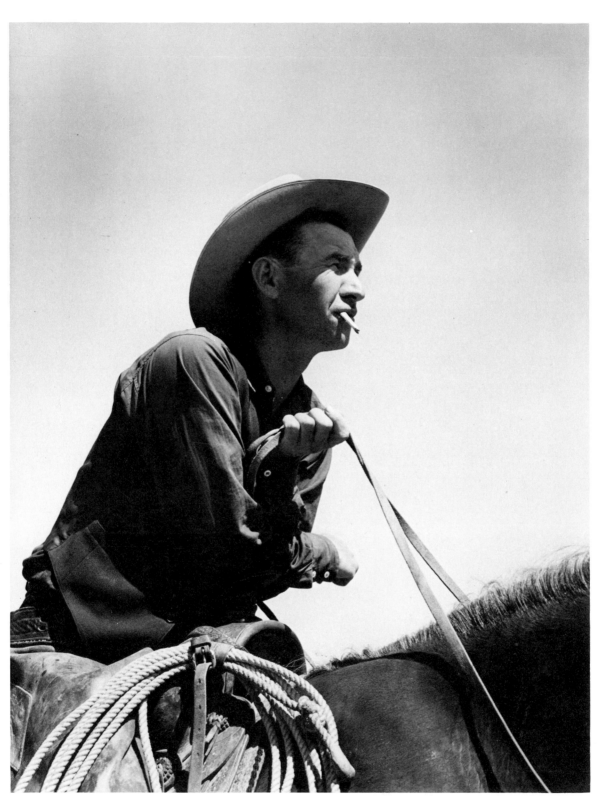

Ranch Cowhand, Custer County, Montana, 1939.
Linhof 9 × 12 cm, with Tessar 13.5 cm lens.
Super Speed Pan film exposed 1/200 sec. at f/8 with a K2
filter.

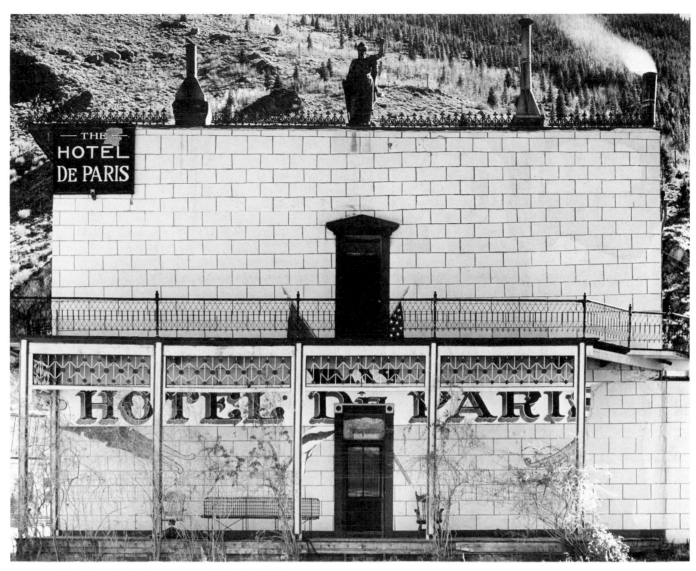

Hotel De Paris, Georgetown, Colorado, 1939.
Linhof 9 × 12 cm, with Double Protar 15 cm lens.
Panatomic film exposed 1/2 sec. at f/32 with a K2 filter.

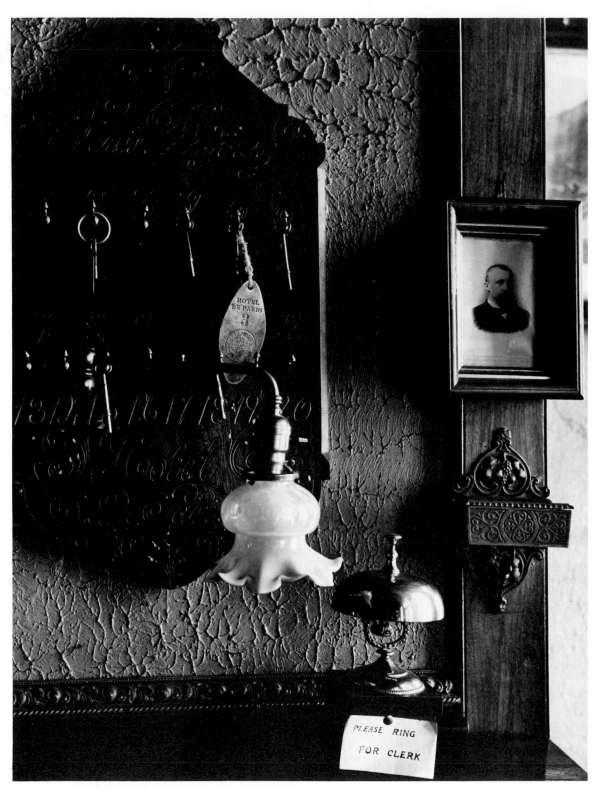

Hotel De Paris, Georgetown, Colorado, 1939.
Linhof 9 × 12 cm, with Double Protar 15 cm lens.
Panatomic film exposed 1/2 sec. at f/6.3.

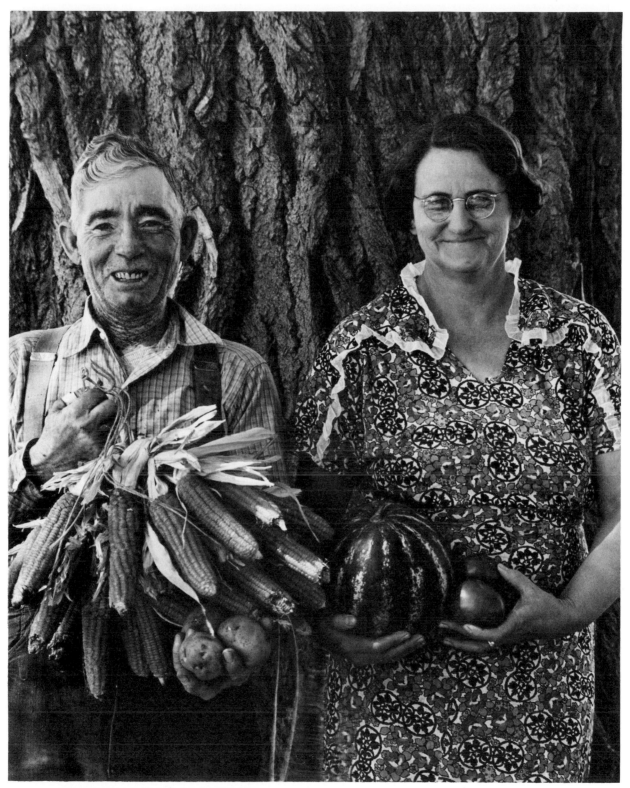

Mr. and Mrs. Andy Bahain on Their Farm
near Kersey, Colorado, 1939.
Linhof 9 × 12 cm, with Double Protar 15 cm lens.
Panatomic film exposed 1/2 sec. at f/16.

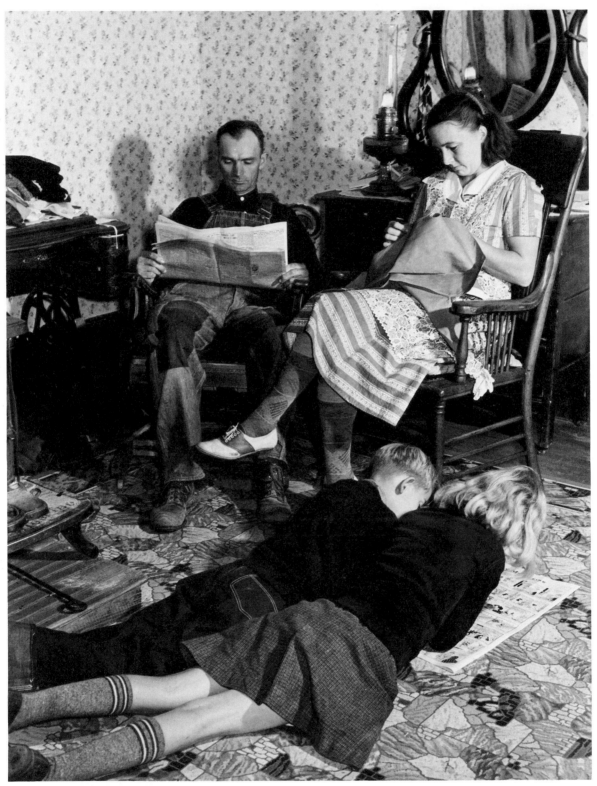

The Dixon Family, St. Charles County, Missouri, 1939.
Linhof 9 × 12 cm, with Tessar 13.5 cm lens.
Panchro Press film exposed 1/100 sec. at f/11 with a Press
40 flashbulb.

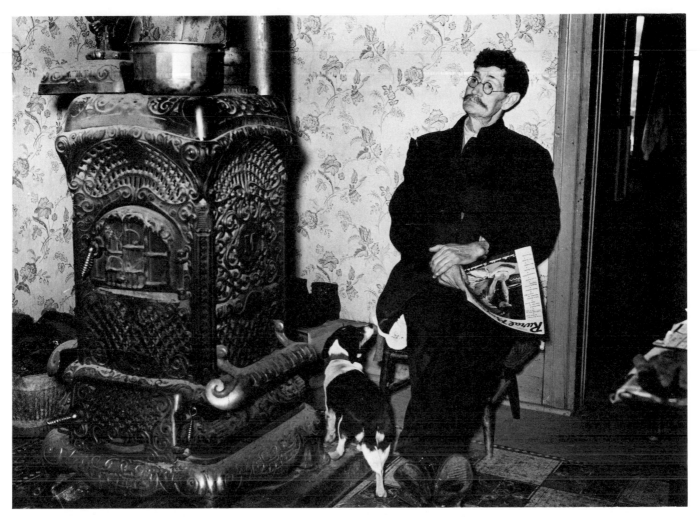

Unemployed Mine Worker, Bush, Illinois, 1939.
Linhof 9 × 12 cm, with Tessar 13.5 cm lens.
Panchro Press film exposed 1/100 sec. at *f*/11 with a Press
40 flashbulb.

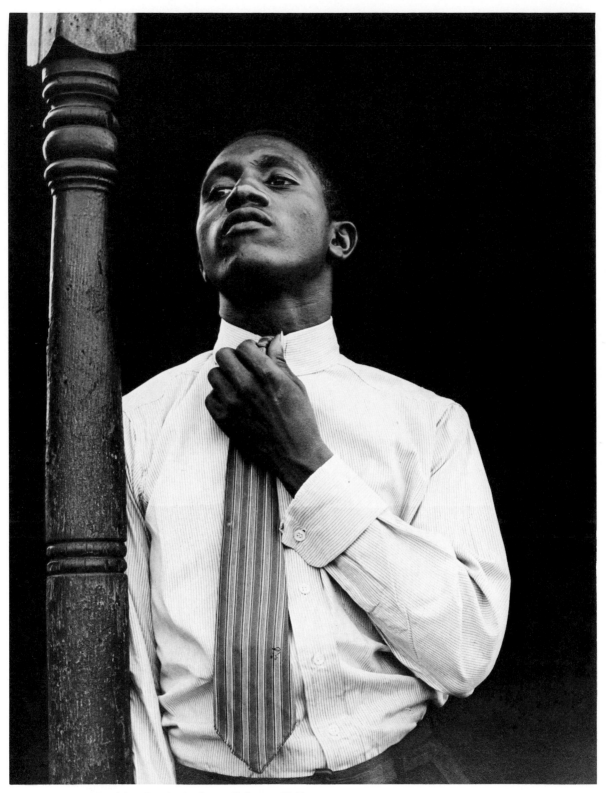

Unemployed Youth, Birmingham, Alabama, 1940.
Speed Graphic 4″ × 5″, with Kodak Anastigmat 127 mm lens.
Super XX film exposed 1/100 sec. at *f*/11.

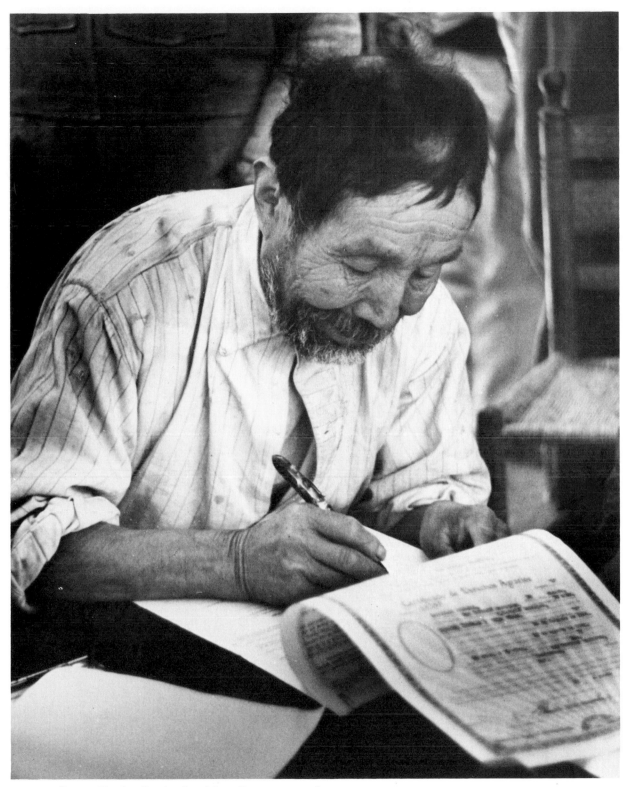

*Farmer Receives Deed to Land from Government under
Agricultural Reform Program, Mexico, 1941.*
Leica IIIf 35 mm, with Elmar 50 mm lens.
Super XX film exposed 1/50 sec. at f/6.3.

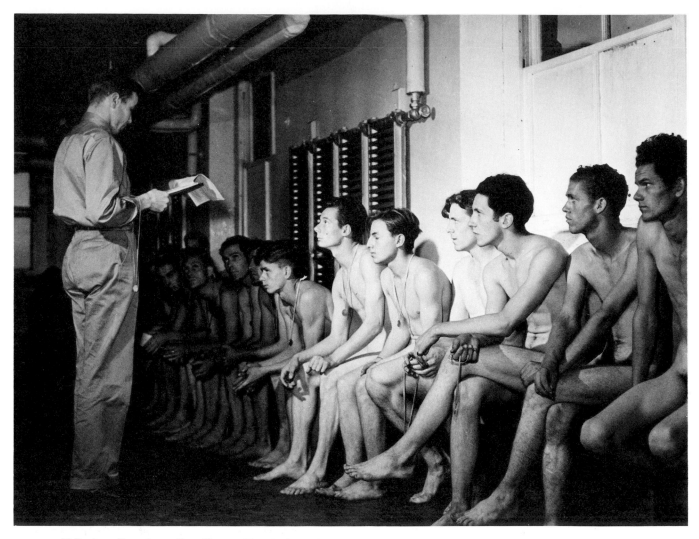

U.S. Army Recruits at Fort Slocum, New York, 1941.
Speed Graphic 4″ × 5″, with Kodak Anastigmat 127 mm lens.
Super Panchro Press film exposed 1/100 sec. at *f*/16 with two
No. 5 flashbulbs.

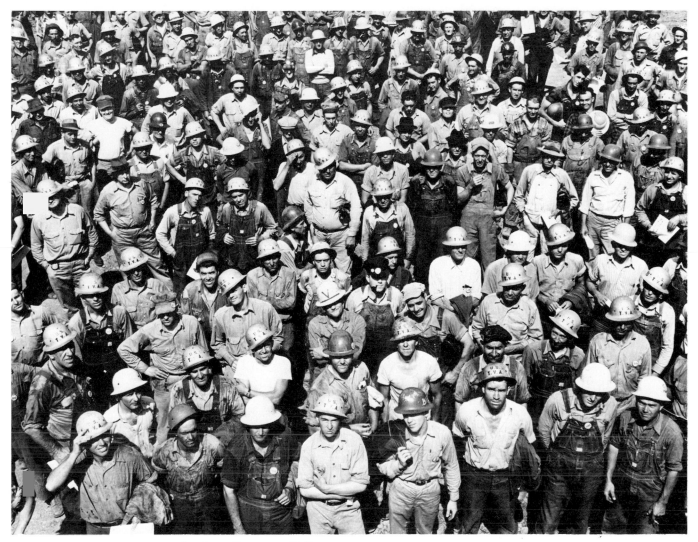

TVA Workers, Fort Loudon Dam, Tennessee, 1942.
Speed Graphic 4″ × 5″, with Kodak Anastigmat 127 mm lens.
Kodachrome film exposed 1/50 sec. at *f*/11. (Black-and-white
conversion shown.)

Enlisted Men's Dance, Charro Days Fiesta, Brownsville,
Texas, 1942.
Speed Graphic 4″ × 5″, with Kodak Anastigmat 127 mm lens.
Super Panchro Press film exposed 1/100 sec. at f/11 with a
No. 5 flashbulb.

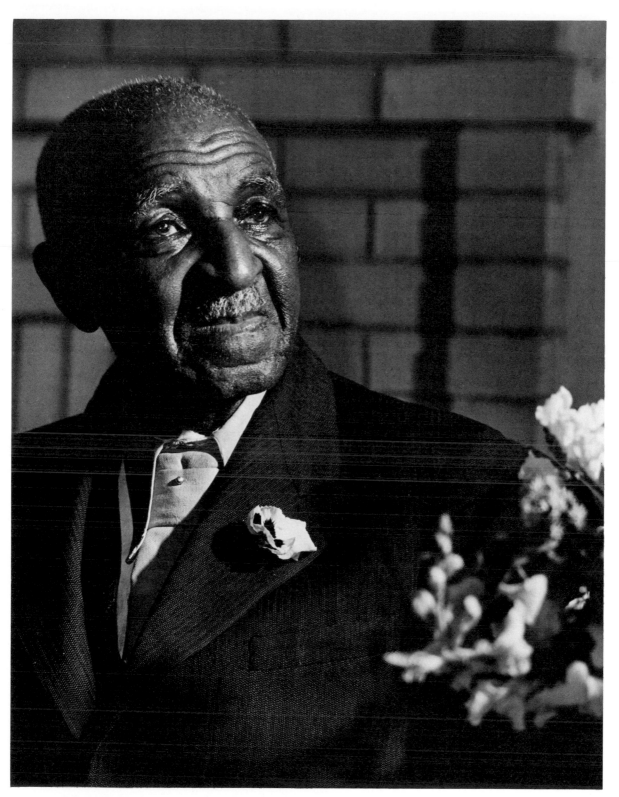

George Washington Carver, Tuskegee, Alabama, 1942.
Korona View 4″ × 5″, with Double Protar 15 cm lens.
Super Panchro Press film exposed 1/100 sec. at f/16 with two
No. 5 flashbulbs.

Mississippi River Flood, St. Louis, Missouri, 1943.
Speed Graphic 4″ × 5″, with Kodak Anastigmat 127 mm lens.
Super Panchro Press film exposed 1/200 sec. at f/8,
photographed from a Ford tri-motor airplane.

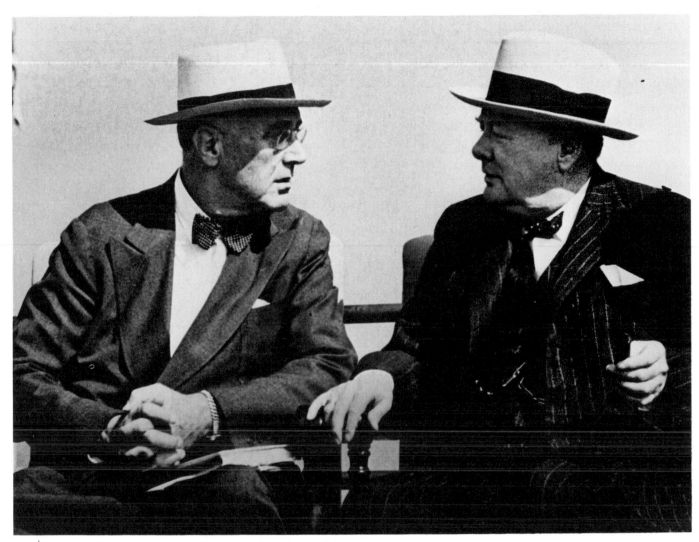

President Franklin D. Roosevelt with Prime Minister
Winston Churchill at Quebec, Canada, 1943.
Graflex 4″ × 5″, with Tessar 250 mm lens.
Super Panchro Press film exposed 1/235 sec. at f/6.3.

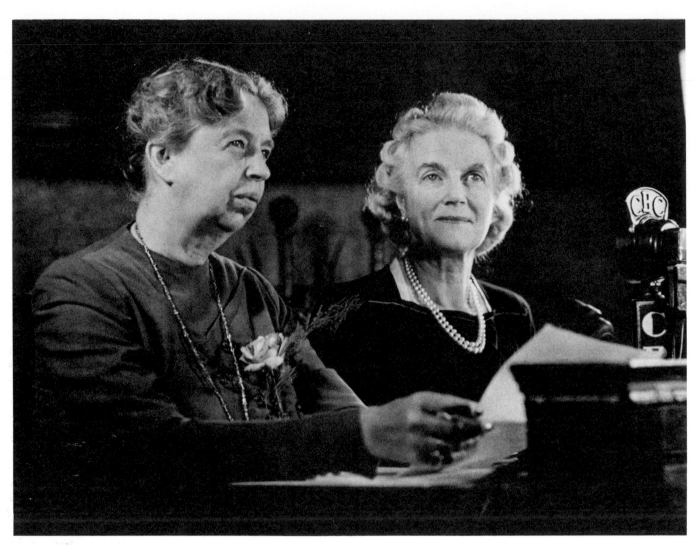

Eleanor Roosevelt and Clementine Churchill at Quebec, Canada, 1943.
Speed Graphic 4″ × 5″, Kodak Anastigmat 127 mm lens.
Super Panchro Press film exposed 1/50 sec. at f/5.6.

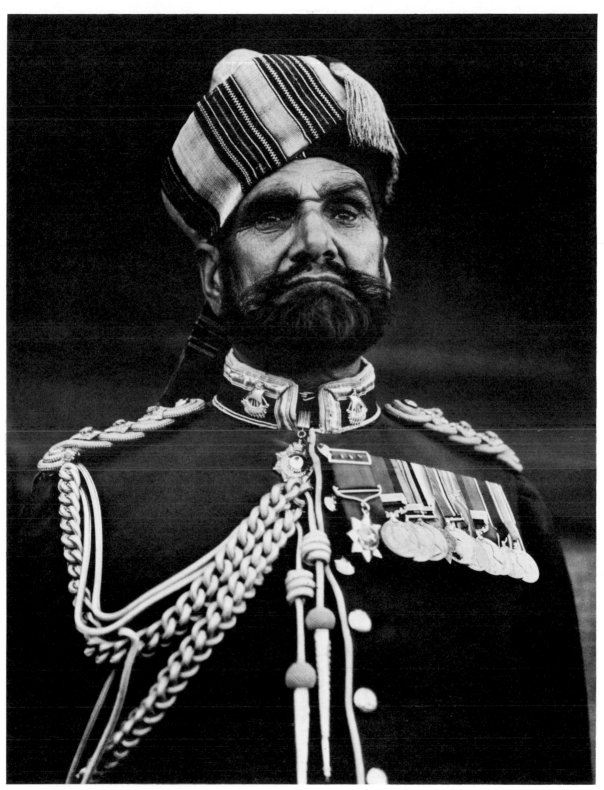

Army Captain, New Delhi, India, 1944.
Speed Graphic 4″ × 5″, with Tessar 150 mm lens.
Super XX film exposed 1/100 sec. at *f*/11.

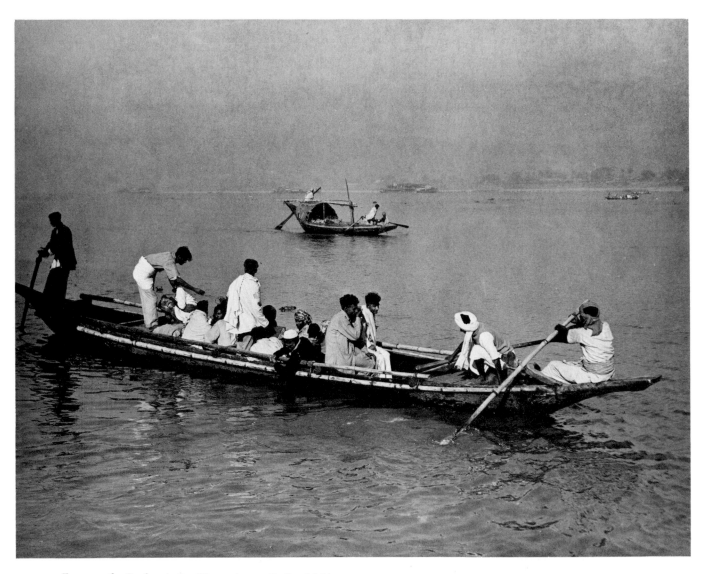

Ferry on the Brahmaputra River, Assam, India, 1944.
Speed Graphic 4″ × 5″, with Tessar 150 mm lens.
Super XX film exposed 1/200 sec. at f/8.

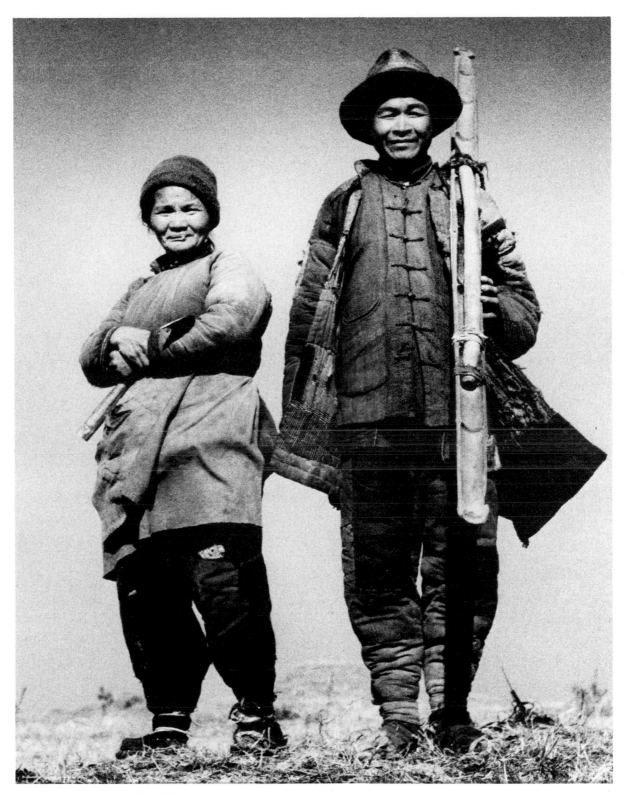

Peasants on a Farm, Kunming, China, 1945.
Rolleiflex 6 × 6 cm.
Super XX film exposed 1/100 sec. at *f*/11.

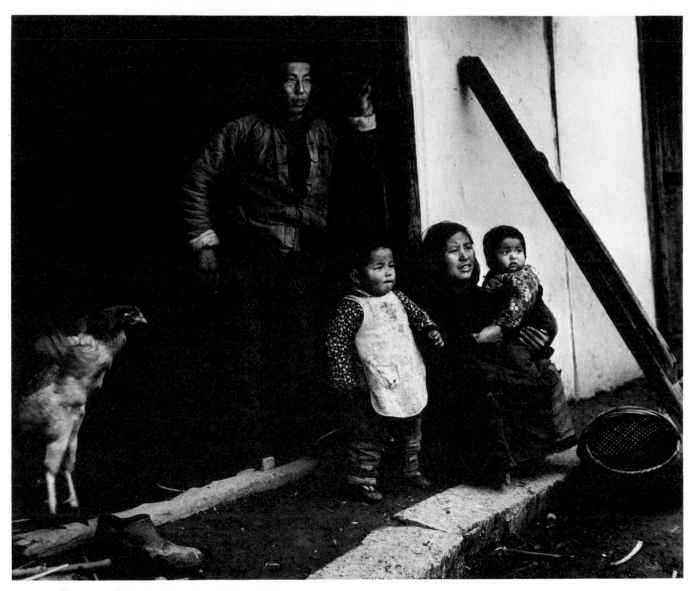

Farmer and Family, Hungjao, China, 1945.
Speed Graphic 4″ × 5″, with Tessar 127 mm lens.
Super XX film exposed 1/50 sec. at f/8.

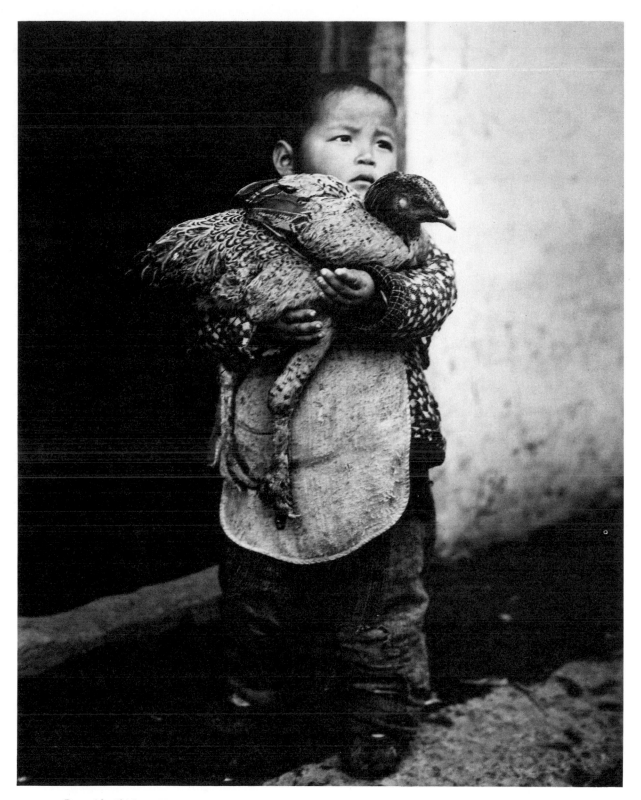

Boy with Chicken, Hungjao, China, 1945.
Rolleiflex 6 × 6 cm.
Super XX film exposed 1/100 sec. at f/5.6.

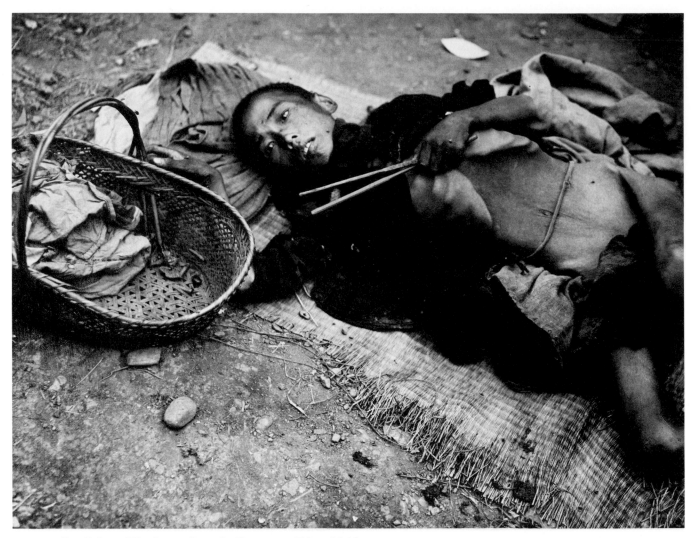

Boy Dying of Famine on Street in Hengyang, China, 1946.
Speed Graphic 4″ × 5″, with Kodak Anastigmat 127 mm lens.
Super XX film exposed 1/100 sec. at f/11.

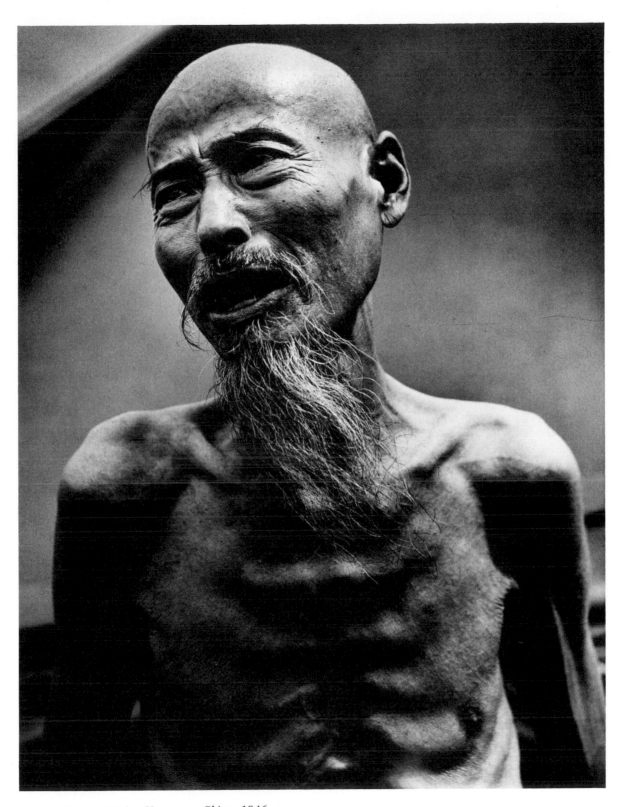

Famine Victim, Hengyang, China, 1946.
Speed Graphic 4″ × 5″, with Kodak Anastigmat 127 mm lens.
Super XX film exposed 1/100 sec. at f/11.

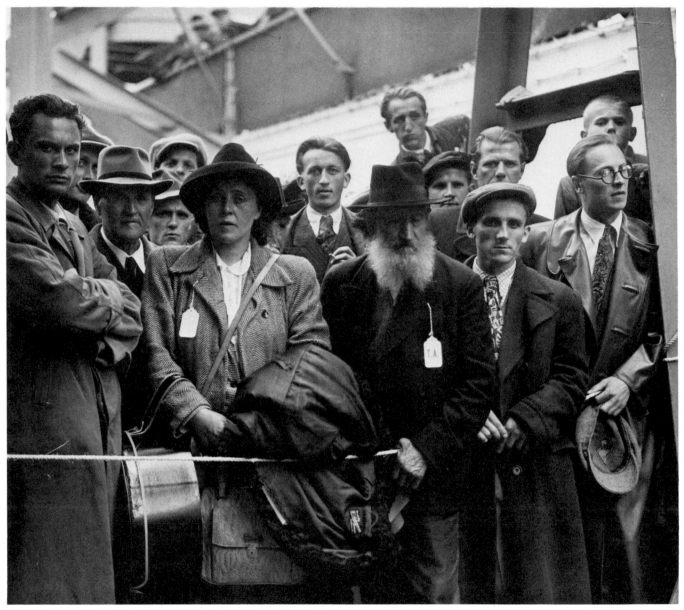

Refugees from Europe Arrive in New York City, 1946.
Speed Graphic 4″ × 5″, with Tessar 150 mm lens.
Super XX film exposed 1/195 sec. at *f*/8.

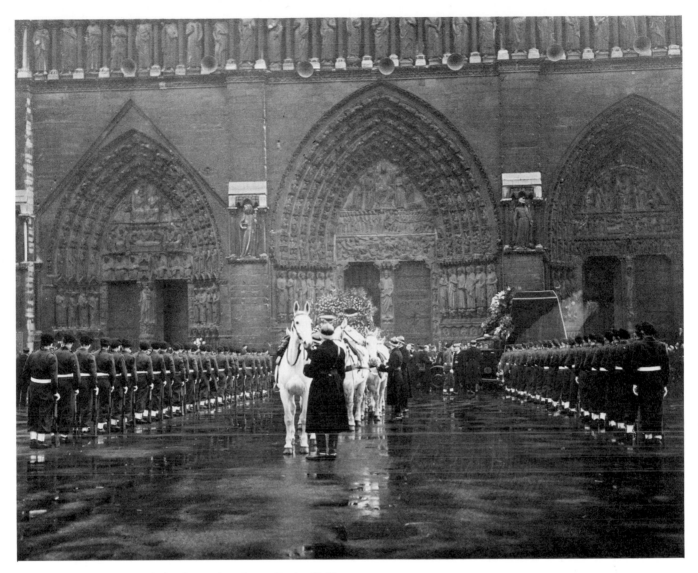

Funeral of General Le Clerc, Nôtre Dame, Paris, 1947.
Speed Graphic 4″ × 5″, with Tessar 150 mm lens.
Super XX film exposed 1/100 sec. at f/5.6.

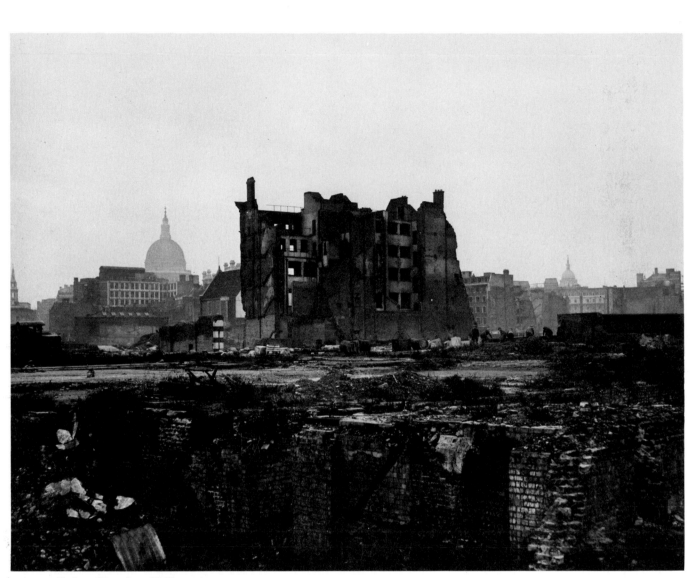

Ruins of London, 1947.
Speed Graphic 4″ × 5″, with Tessar 150 mm lens.
Super XX film exposed 1/230 sec. at f/8.

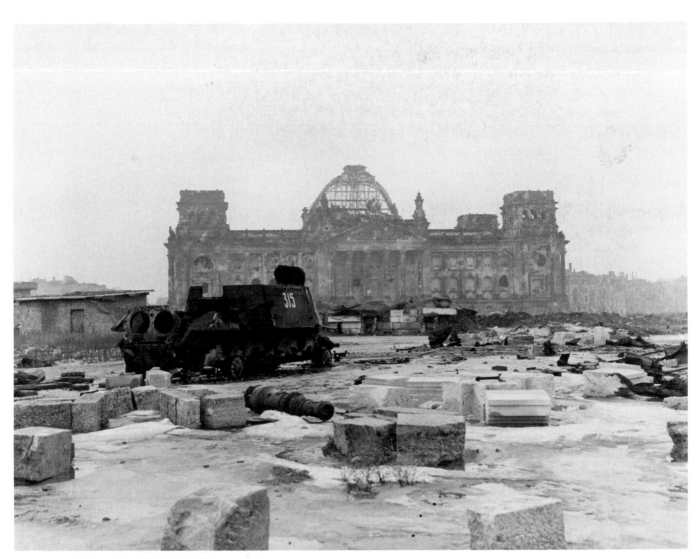

Reichstag Ruins, Berlin, 1947.
Speed Graphic 4″ × 5″, with Tessar 150 mm lens.
Super XX film exposed 1/230 sec. at f/8.

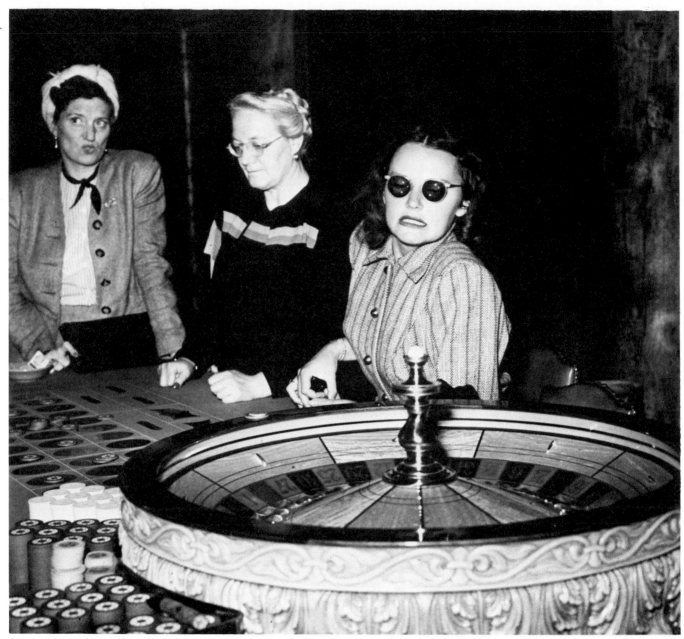

Gamblers, Las Vegas, Nevada, 1947.
Speed Graphic 4″ × 5″, with Kodak Anastigmat 127 mm lens.
Super XX film exposed 1/100 sec. at *f*/16.

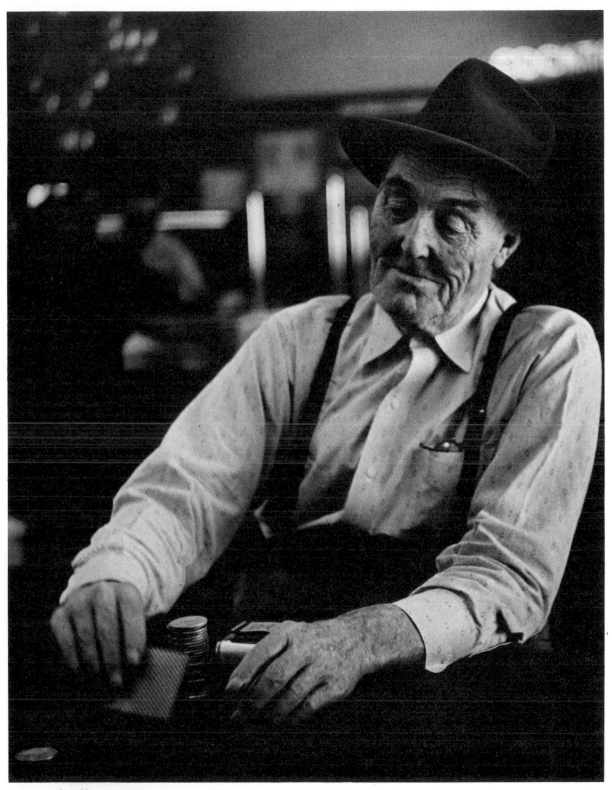

Gambler, Las Vegas, Nevada, 1947.
Rolleiflex 6 × 6 cm.
Super XX film exposed 1/50 sec. at f/3.5.

Beer Drinker at Grafton's Pub, London, 1947.
Speed Graphic 4″ × 5″, with Kodak Anastigmat 127 mm lens.
Super XX film exposed 1/100 sec. at f/11 with a No. 5
flashbulb.

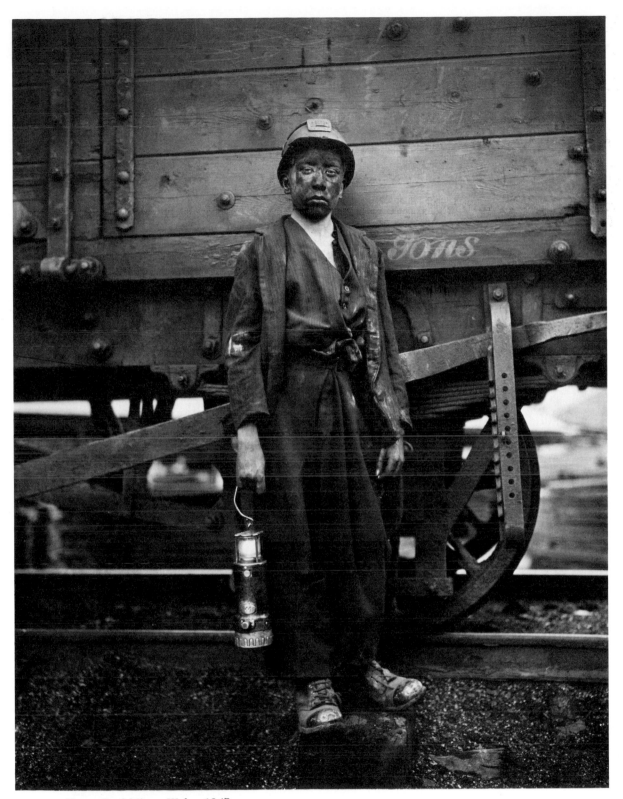

Young Coal Miner, Wales, 1947.
Speed Graphic 4″ × 5″, with Kodak Anastigmat 127 mm lens.
Super XX film exposed 1/50 sec. at f/8.

Rally for De Gaulle, Paris, 1947.
Speed Graphic 4″ × 5″, with Kodak Anastigmat 127 mm lens.
Super XX film exposed 1 sec. at f/4.5.

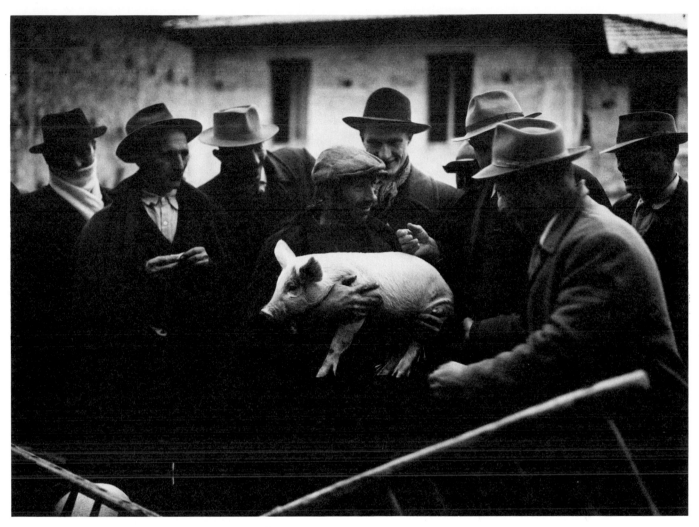

Farmers in the Market, Tocco, Italy, 1947.
Speed Graphic 4″ × 5″, with Kodak Anastigmat 127 mm lens.
Super XX film exposed 1/50 sec. at *f*/8.

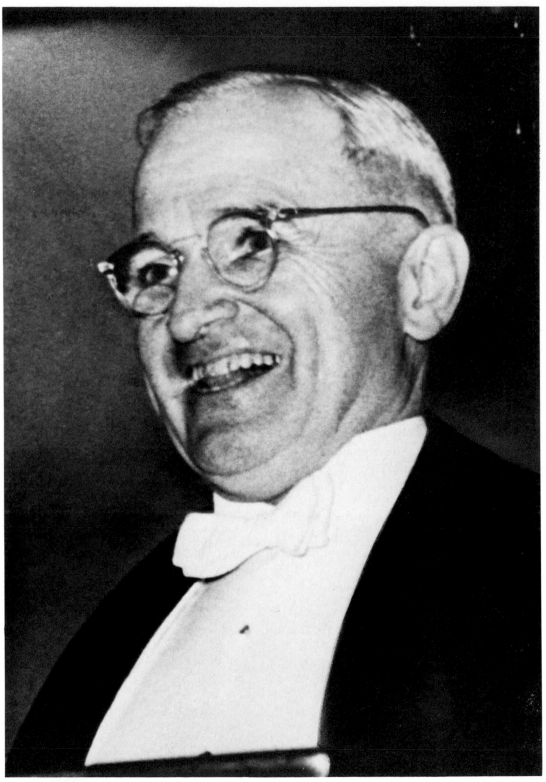

President Harry Truman, 1948.
Speed Graphic 4″ × 5″, with Kodak Anastigmat 127 mm lens.
Super XX film exposed 1/100 sec. at *f*/8 with a No. 5
flashbulb.

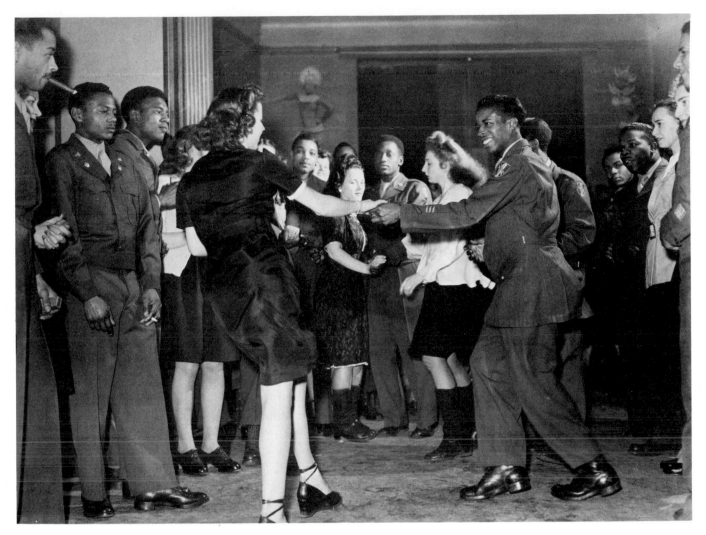

U.S. Army Soldiers at a Dance, Vienna, Austria, 1948.
Speed Graphic 4″ × 5″, with Kodak Anastigmat 127 mm lens.
Super XX film exposed 1/200 sec. at f/11 with two No. 5
flashbulbs.

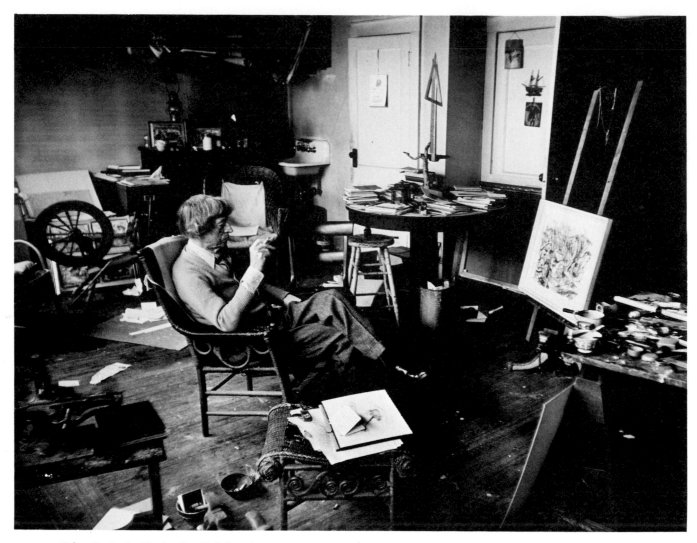

John Marin in His Studio, Hoboken, New Jersey, 1949.
Deardorff 4″ × 5″, with Schneider Angulon 90 mm lens.
Super XX film exposed 1 sec. at f/11.

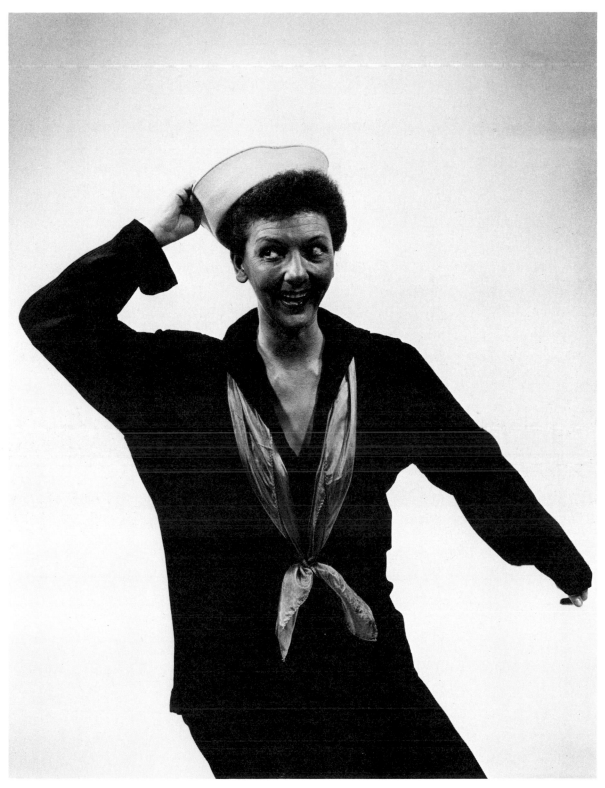

Mary Martin, 1949.
Deardorff 4″ × 5″, with Tessar 150 mm lens.
Panatomic-X film with electronic flash.

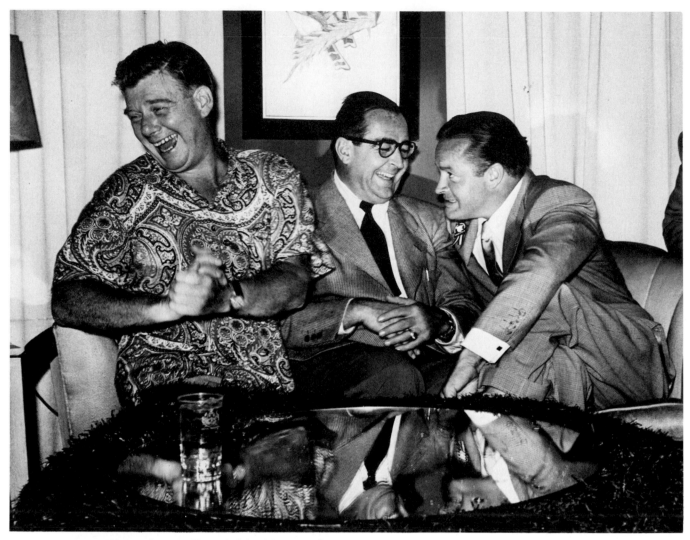

(*Left to right*) *Arthur Godfrey, Cedric Adams, and
Bob Hope in Minneapolis, Minnesota, 1949.*
Speed Graphic 4″ × 5″, with Kodak Anastigmat 127 mm lens.
Super XX film exposed 1/100 sec. at f/11 with a No. 5
flashbulb.

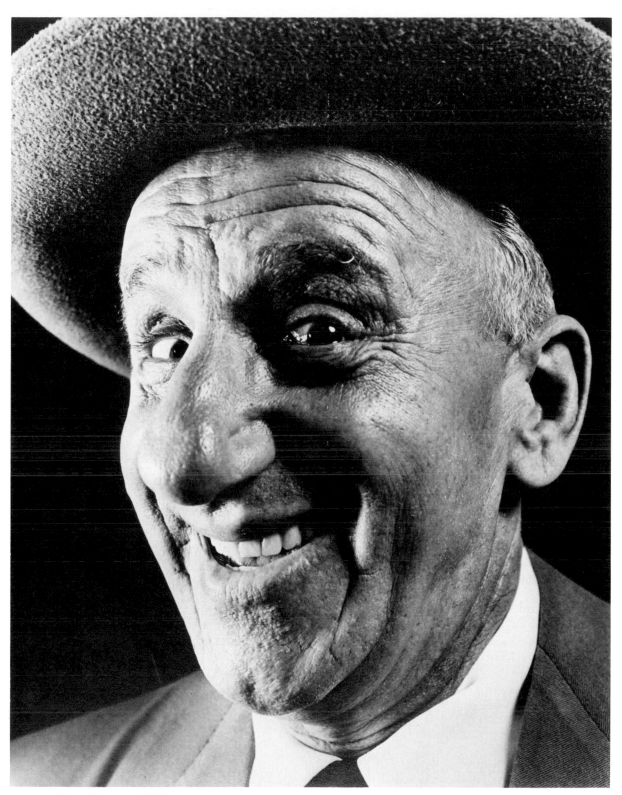

Jimmy Durante, 1950.
Hill 4″ × 5″, with 180-degree lens.
Super XX film with electronic flash.

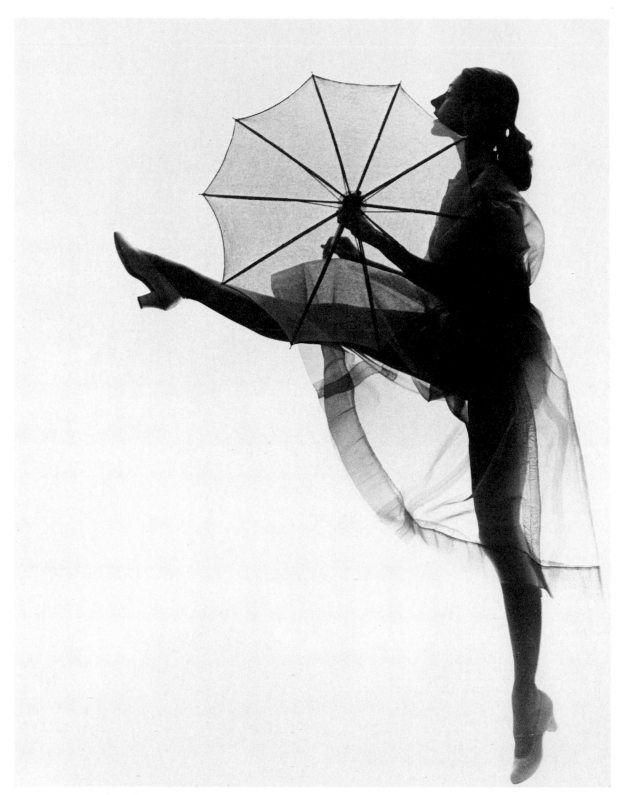

Tanaquil LeClercq, Ballerina, 1950.
Deardorff 4″ × 5″, with Tessar 150 mm lens.
Panatomic-X film with electronic flash.

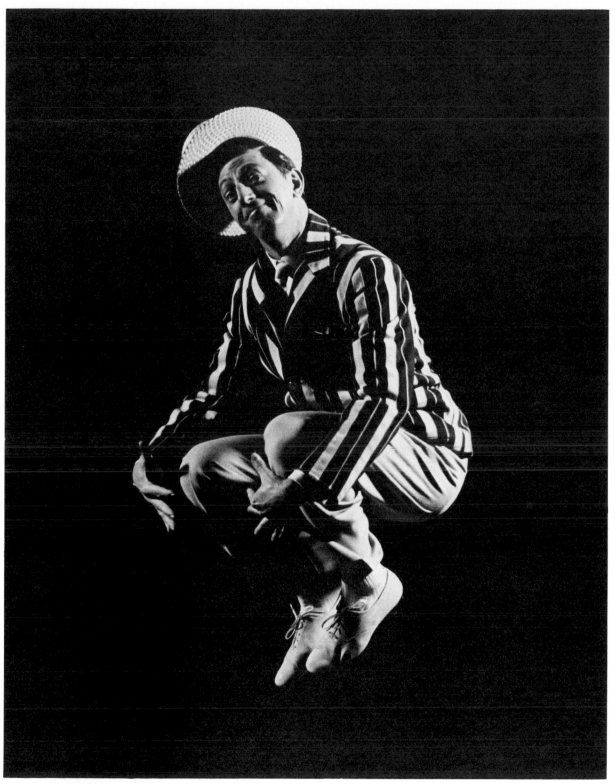

Ray Bolger, 1950.
Deardorff 4″ × 5″, with Tessar 150 mm lens.
Panatomic-X film with electronic flash.

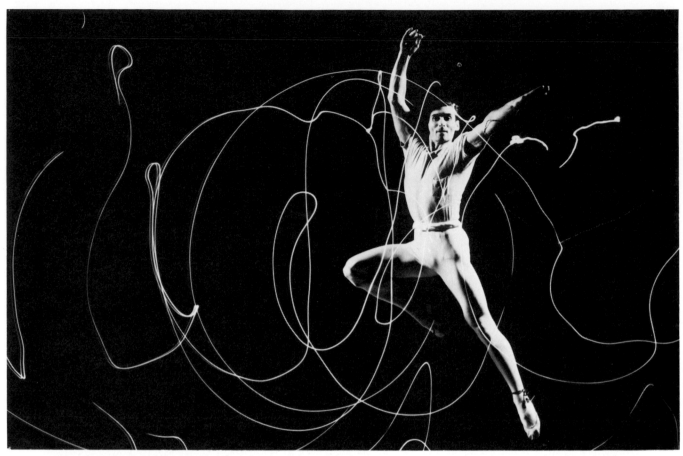

Igor Youskevitch, Ballet Dancer, 1950.
Deardorff 4" × 5", with Tessar 150 mm lens.
Panatomic-X film. Using a black velvet background, lights
on dancer's hands and feet recorded during a two-second
exposure, then figure exposed with electronic flash.

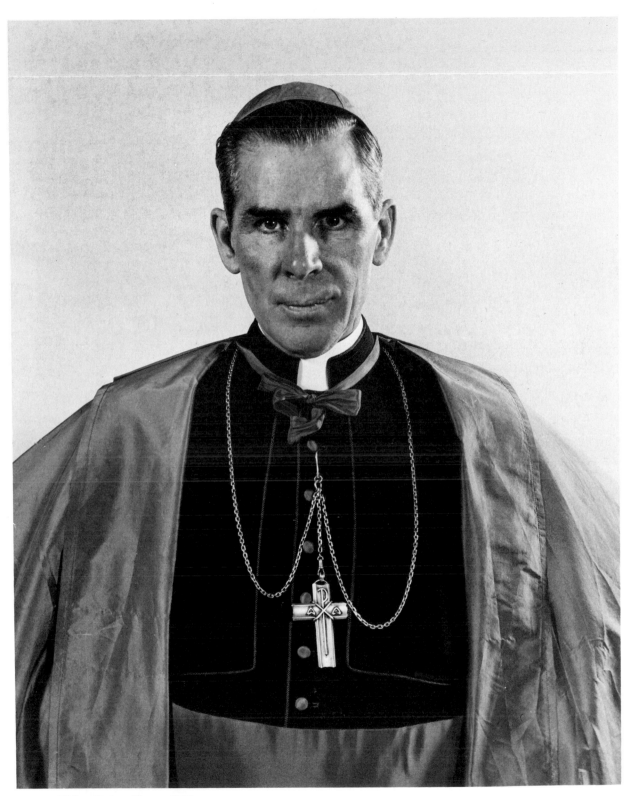

Bishop Fulton Sheen, 1951.
Deardorff 8″ × 10″, with Ektar 30 cm lens.
Ektachrome film with electronic flash. (Black-and-white conversion shown.)

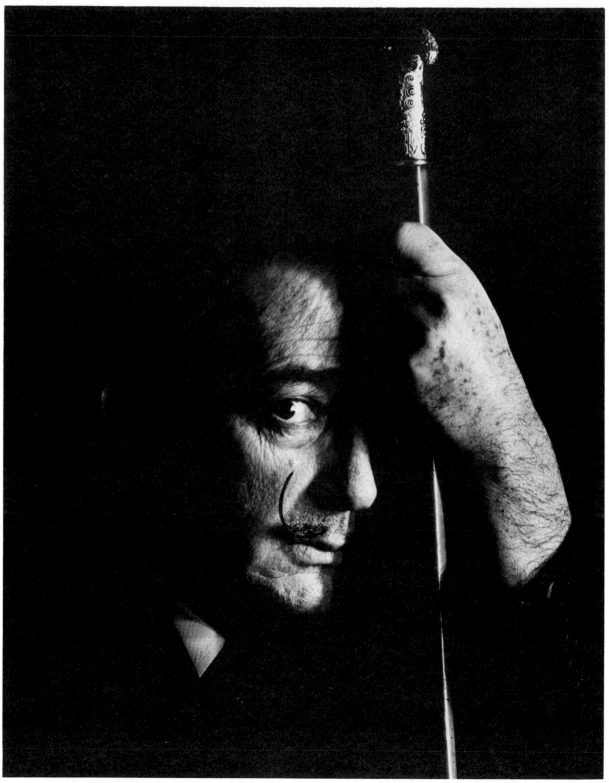

Salvador Dali, 1951.
Deardorff 4″ × 5″, with Tessar 150 mm lens.
Panatomic-X film with electronic flash.

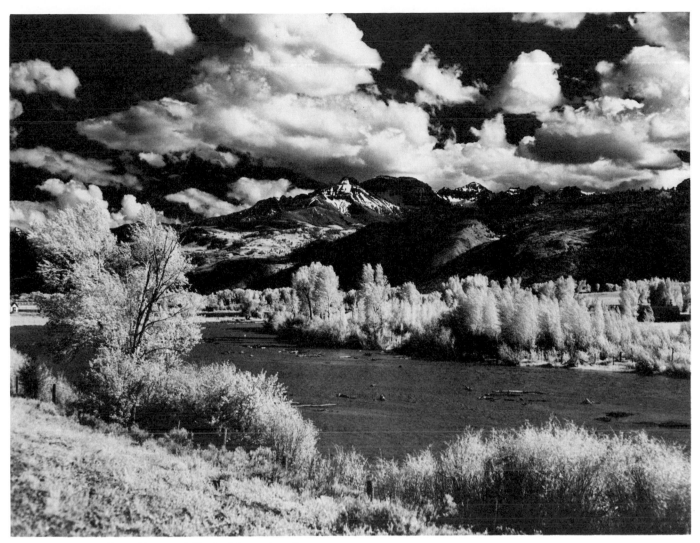

Uncompahgre River and Rocky Mountains, Ouray, Colorado, 1952.
Speed Graphic 4″ × 5″, with Kodak Anastigmat 127 mm lens.
Infrared film exposed 1/10 sec. at f/16 with a No. 25 filter.

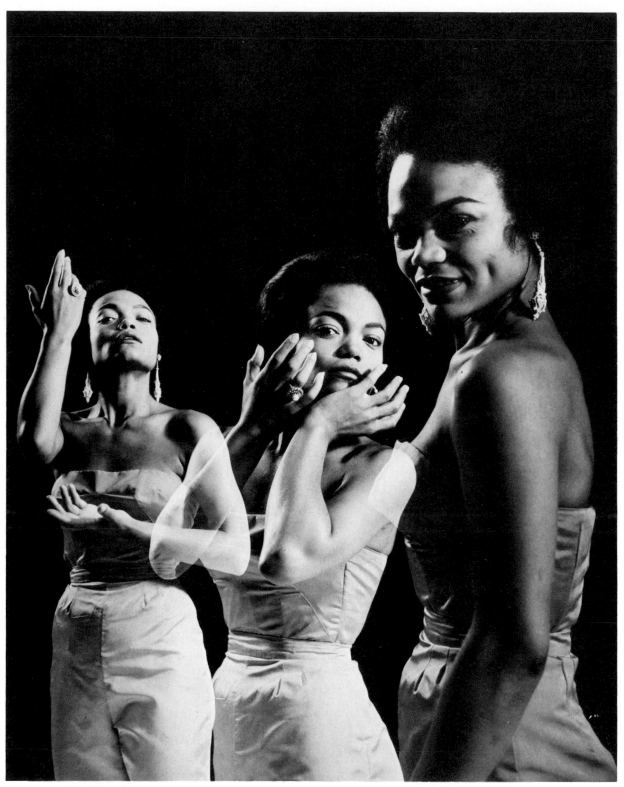

Eartha Kitt, 1953.
Deardorff 8″ × 10″, with Ektar 30 cm lens.
Ektachrome film exposed three times with electronic flash on black velvet background. (Black-and-white conversion shown.)

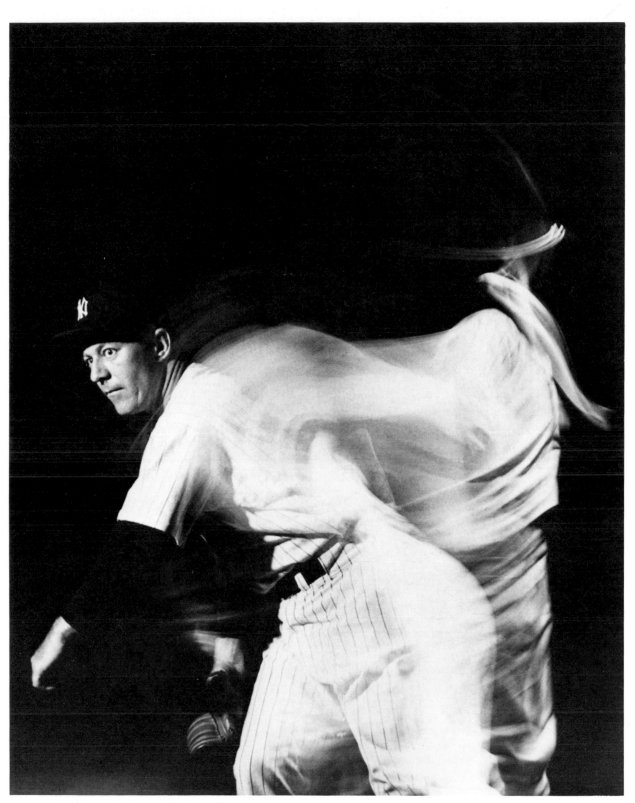

Eddie Lopat, Yankee Pitcher, 1954.
Deardorff 4″ × 5″, with Tessar 150 mm lens.
Super XX film exposed twice, one second with tungsten light
for windup, followed by electronic flash.

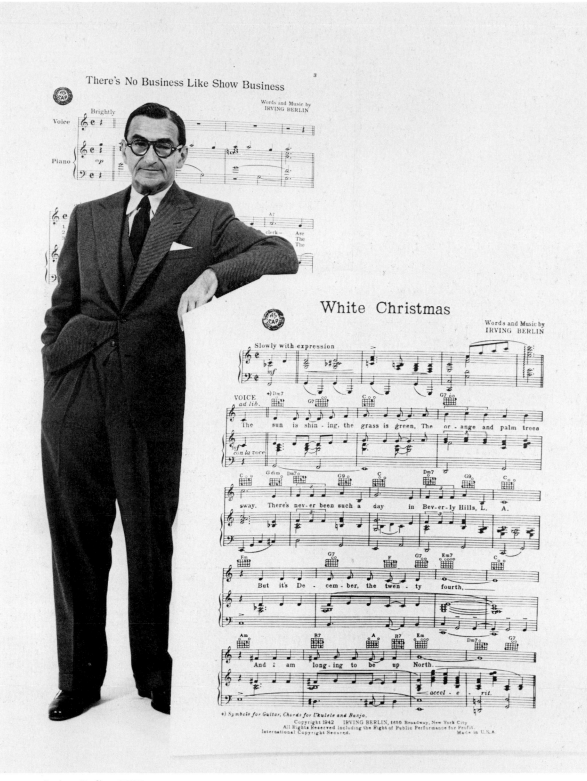

Irving Berlin, 1955.
Deardorff 4″ × 5″, with Tessar 150 mm lens.
Panatomic-X film with electronic flash.

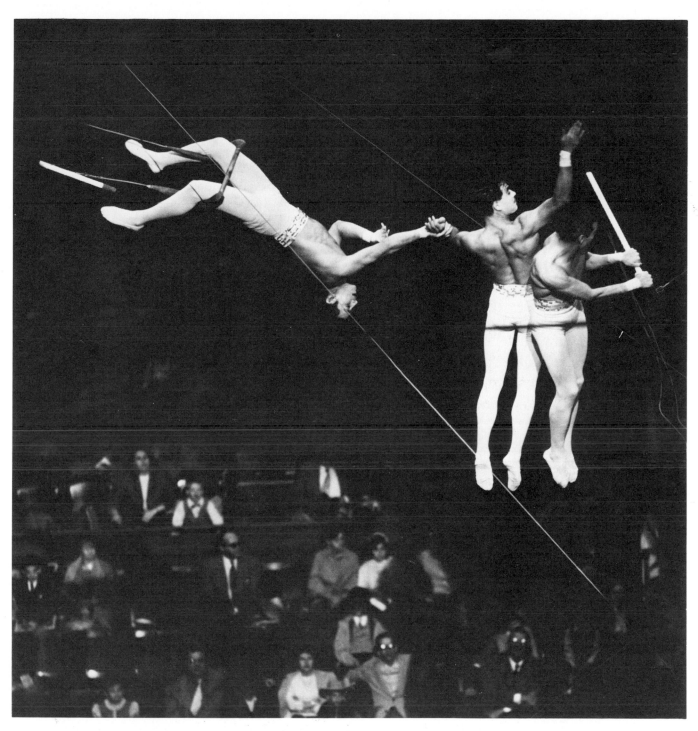

Trapeze Act, Ringling Brothers Circus, New York City, 1955.
Nikon F 35 mm, with 300 mm lens.
Tri-X film exposed 1/500 sec. at f/4.

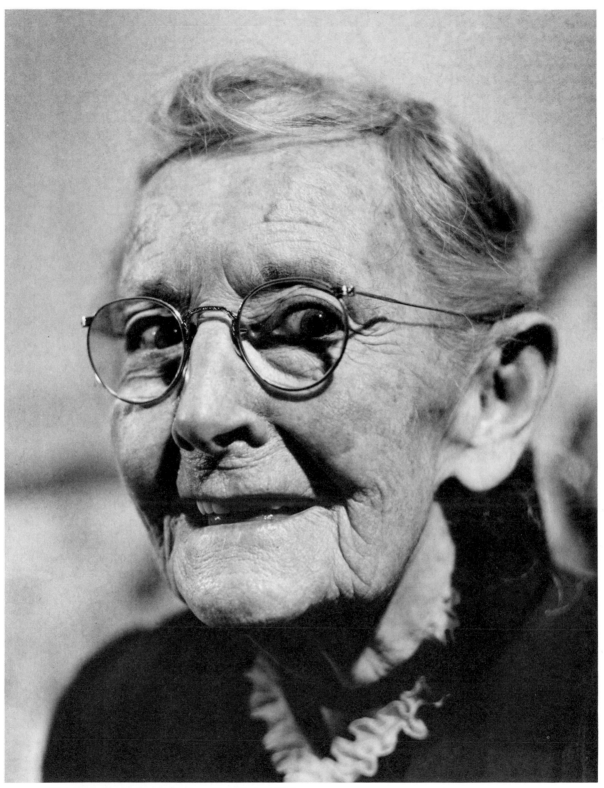

Grandma Moses, Eagle Bridge, New York, 1956.
Hasselblad 6 × 6 cm, with 180 mm lens.
Tri-X film exposed 1/50 sec. at f/8.

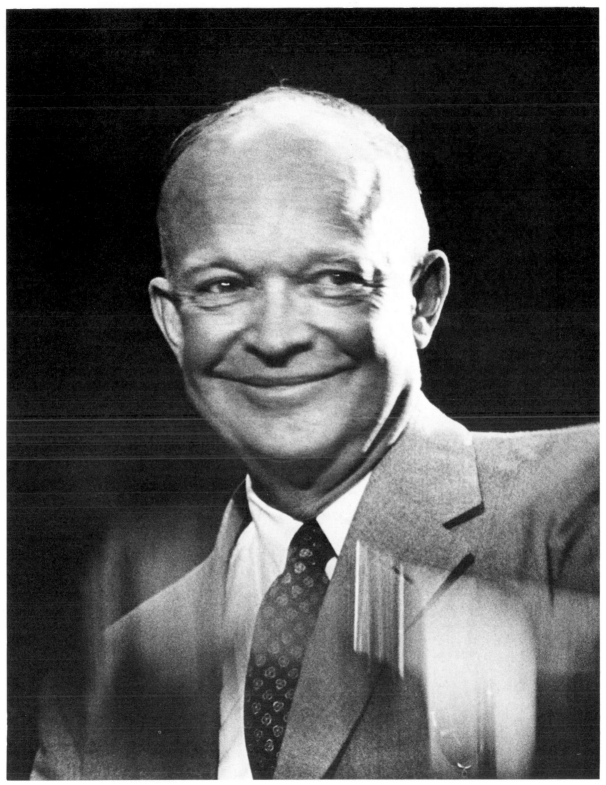

President Dwight D. Eisenhower, 1956.
Nikon F 35 mm, with 105 mm lens.
Tri-X film exposed 1/60 sec. at f/4.

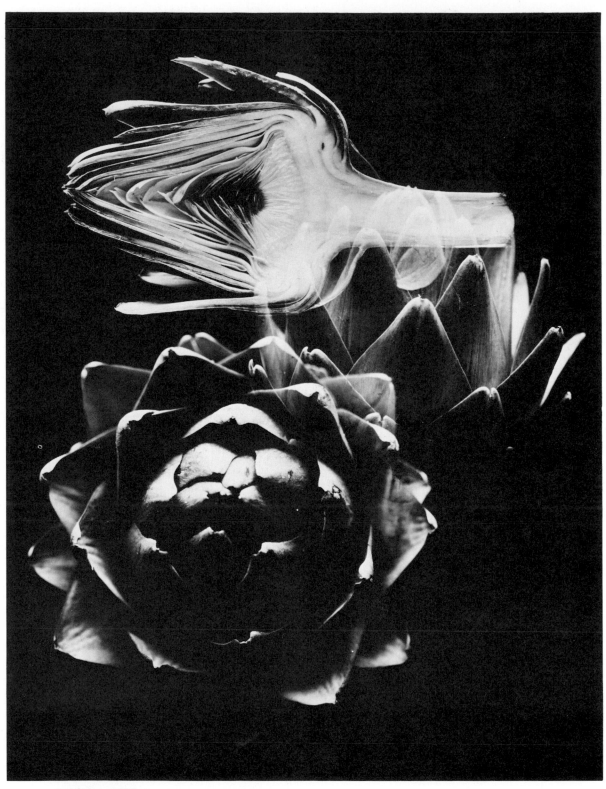

Artichokes, 1958.
Deardorff 8″ × 10″, with Ektar 30 cm lens.
Ektachrome film exposed three times with tungsten light.
(Black-and-white conversion shown.)

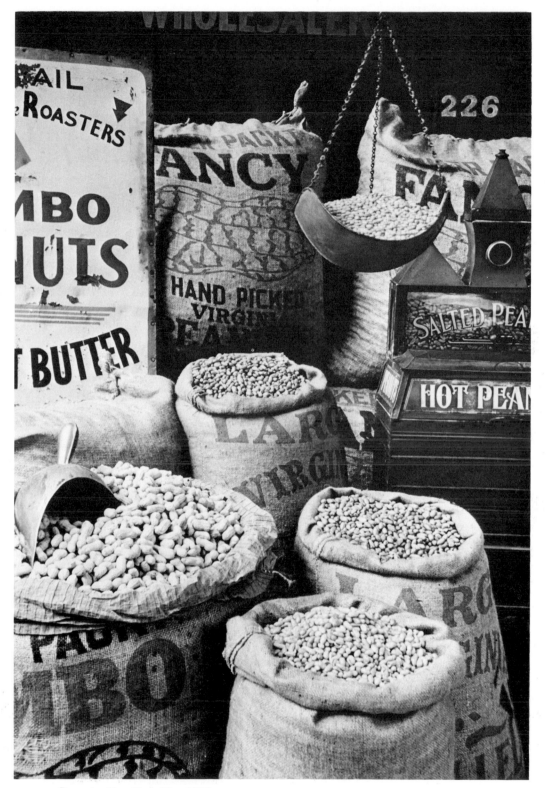

Peanuts, New York City, 1958.
Nikon F 35 mm, with 50 mm lens.
Kodachrome film exposed 1/4 sec. at f/11.
(Black-and-white conversion shown.)

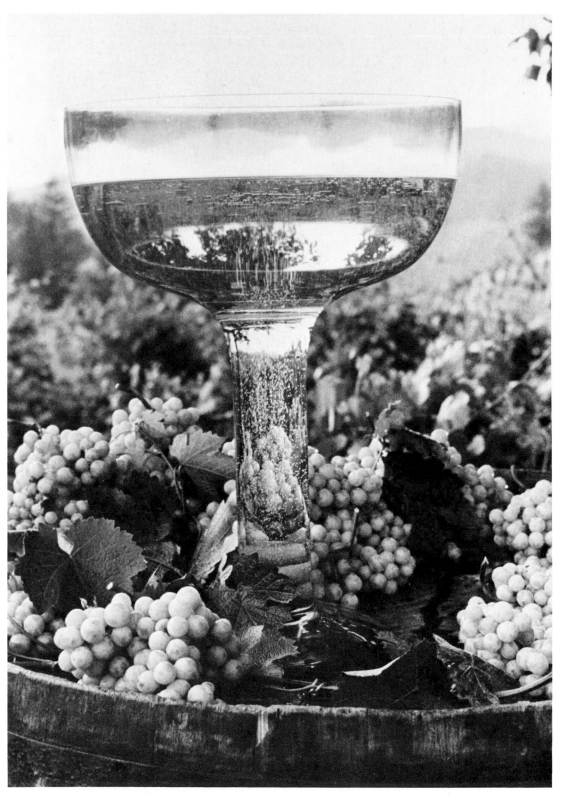

Champagne, California, 1959.
Nikon F 35 mm, with 28 mm lens.
High-Speed Ektachrome film exposed 1/500 sec. at *f*/8.
(Black-and-white conversion shown.)

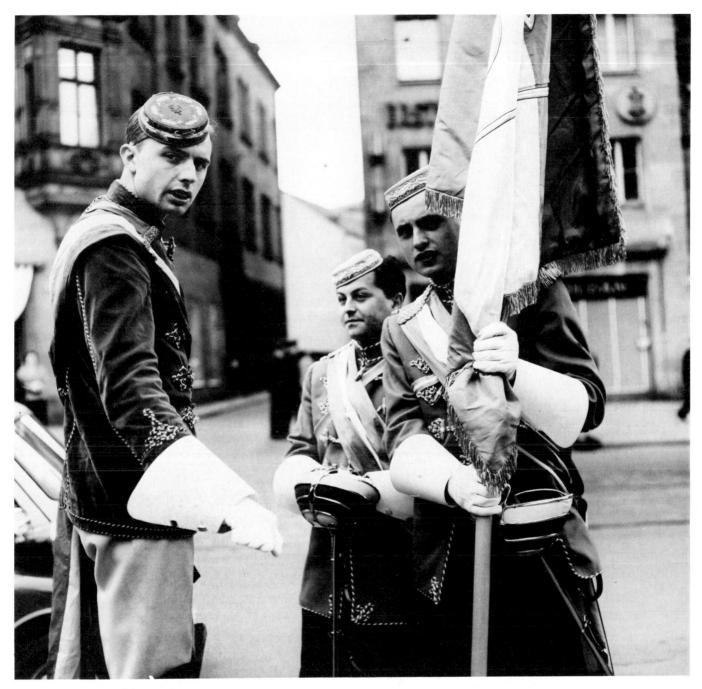

Students, Nürnberg, Germany, 1959.
Hasselblad 6 × 6 cm, with Ektar 80 mm lens.
Plus-X film exposed 1/250 sec. at f/8.

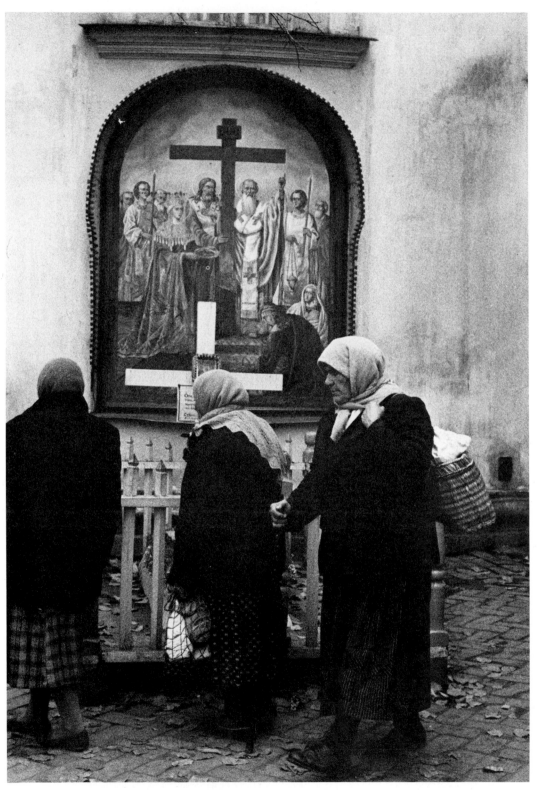

Religious Women at Russian Orthodox Church near Kiev,
U.S.S.R., 1960.
Nikon F 35 mm, with 50 mm lens.
Tri-X film exposed 1/125 sec. at f/8.

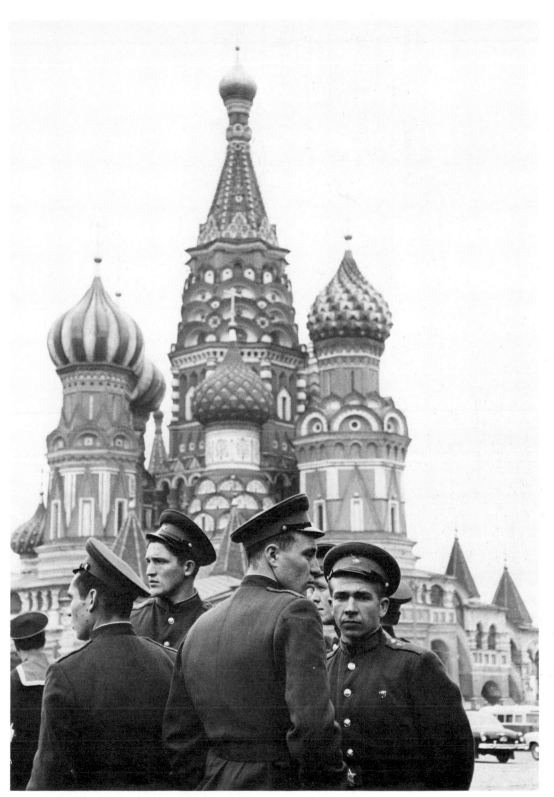

Soldiers in Red Square, Moscow, 1960.
Nikon F 35 mm, with 50 mm lens.
Tri-X film exposed 1/250 sec. at f/16.

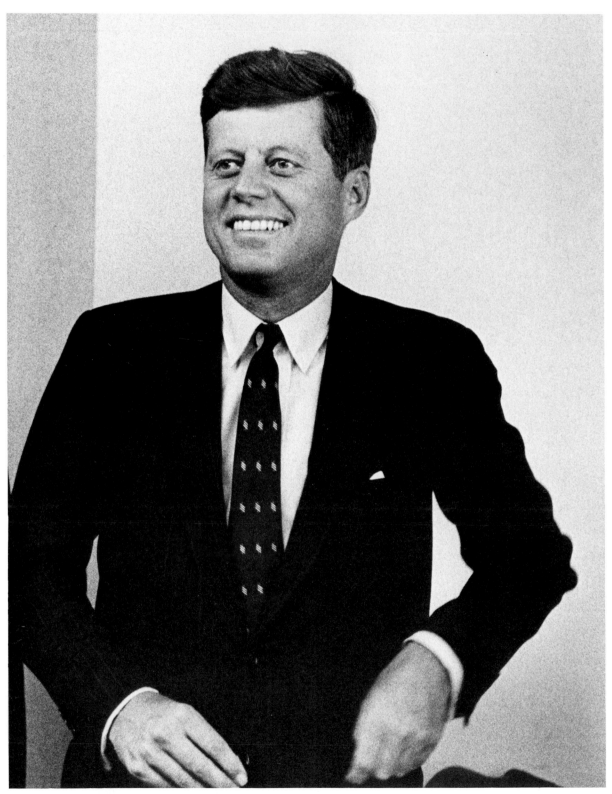

President John F. Kennedy, 1961.
Leica M3 35 mm, with Summicron 50 mm lens.
Tri-X film exposed 1/60 sec. at f/2.8.

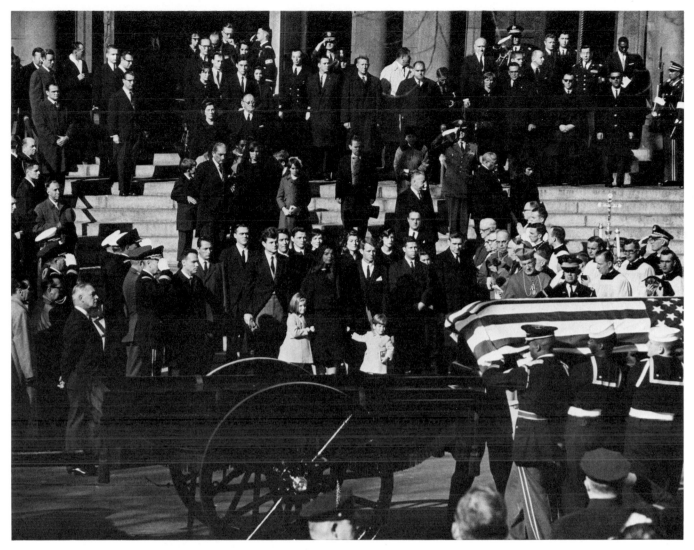

Funeral of President Kennedy, Washington, D.C., 1963.
Nikon F 35 mm, with 500 mm lens.
Tri-X film exposed 1/500 sec. at f/11.

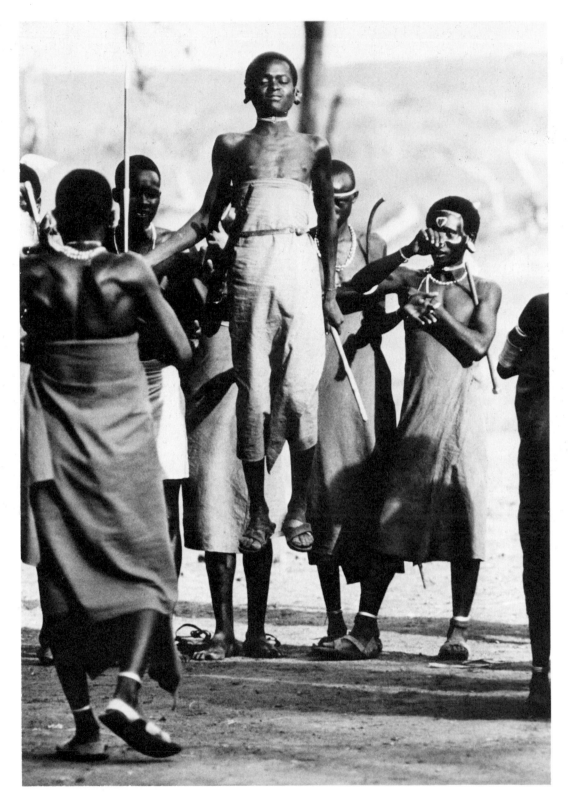

Dancers of the Samburu Tribe, Kenya, 1964.
Nikon F 35 mm with 50 mm lens.
Plus-X film exposed 1/500 sec. at f/5.6.

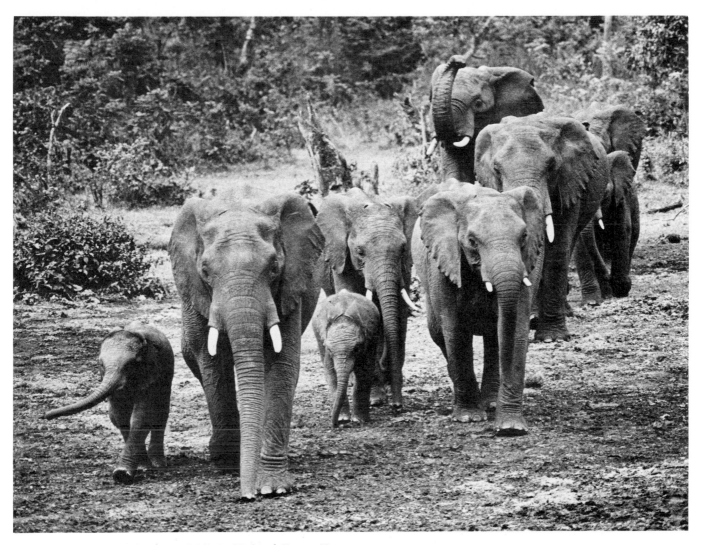

A Herd of Elephants, Aberdares National Forest, Kenya,
1964.
Nikon F 35 mm, with 500 mm lens.
Tri-X film exposed 1/500 sec. at f/8.

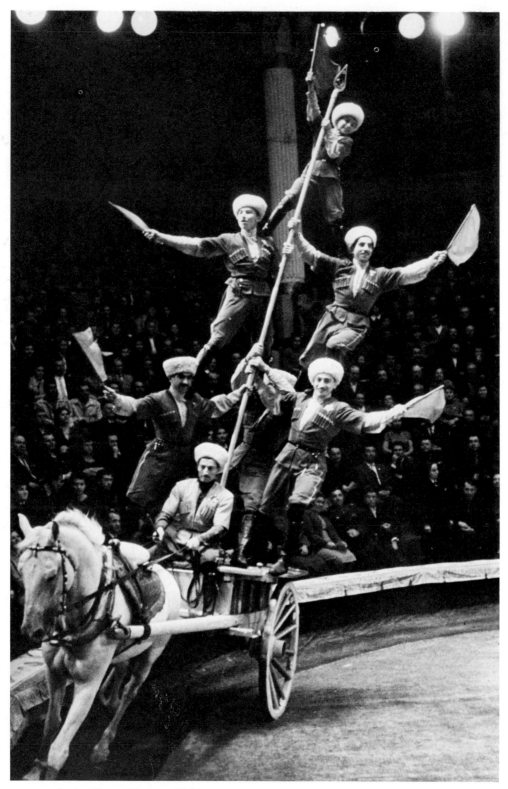

At the Circus, Moscow, 1964.
Nikon F 35 mm with 105 mm lens.
High-Speed Ektachrome film exposed 1/500 sec. at *f*/4.
(Black-and-white conversion shown.)

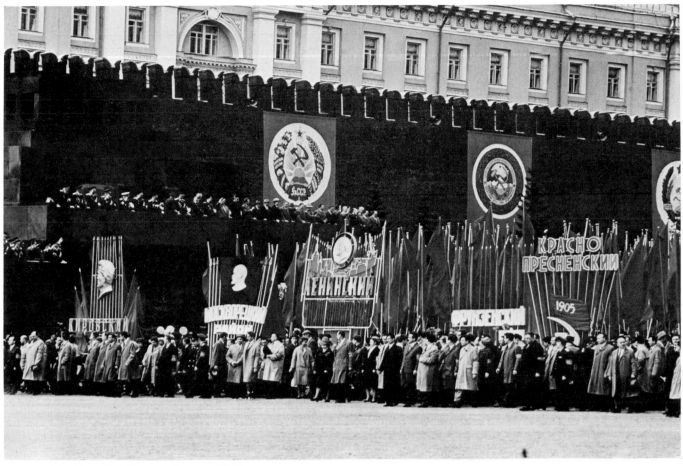

May Day, Red Square, Moscow, 1964.
Nikon F 35 mm, with 300 mm lens.
Ektachrome film exposed 1/250 sec. at *f*/8. (Black-and-white
conversion shown.)

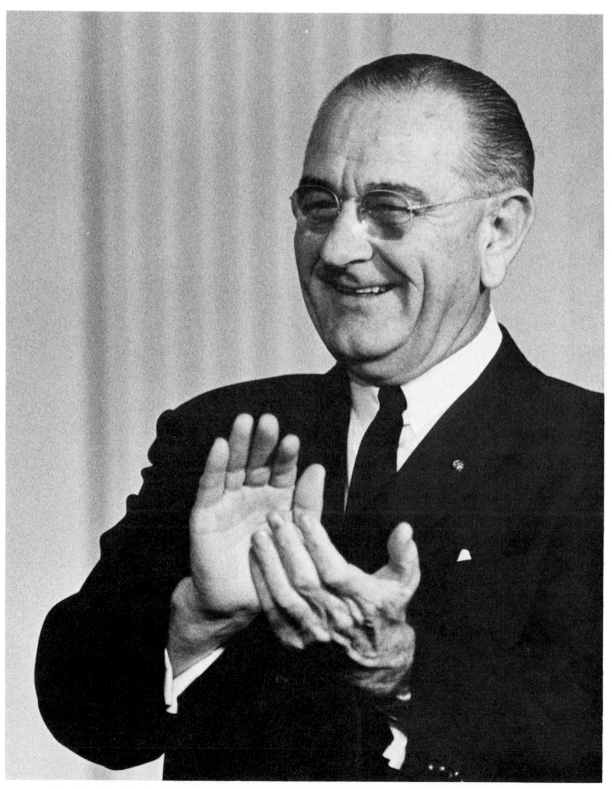

President Lyndon B. Johnson, 1967.
Nikon F 35 mm, with 105 mm lens.
Tri-X film exposed 1/125 sec. at f/4.

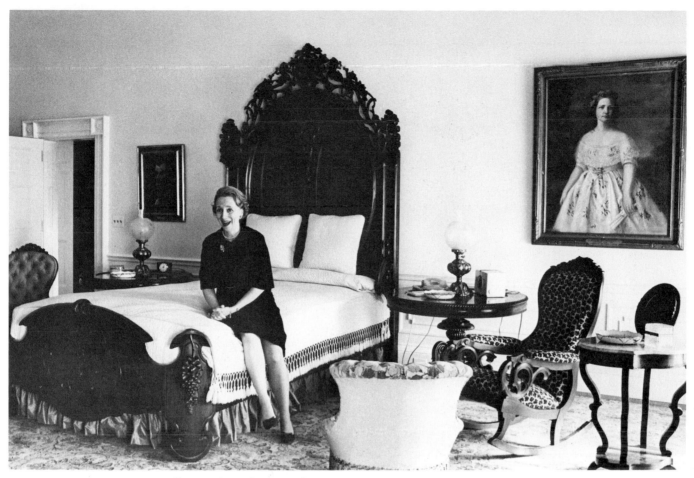

Margaret Truman in the Lincoln Bedroom at the White House, 1967.
Nikon F 35 mm, with 24 mm lens.
Tri-X film exposed 1/60 sec. at f/2.8.

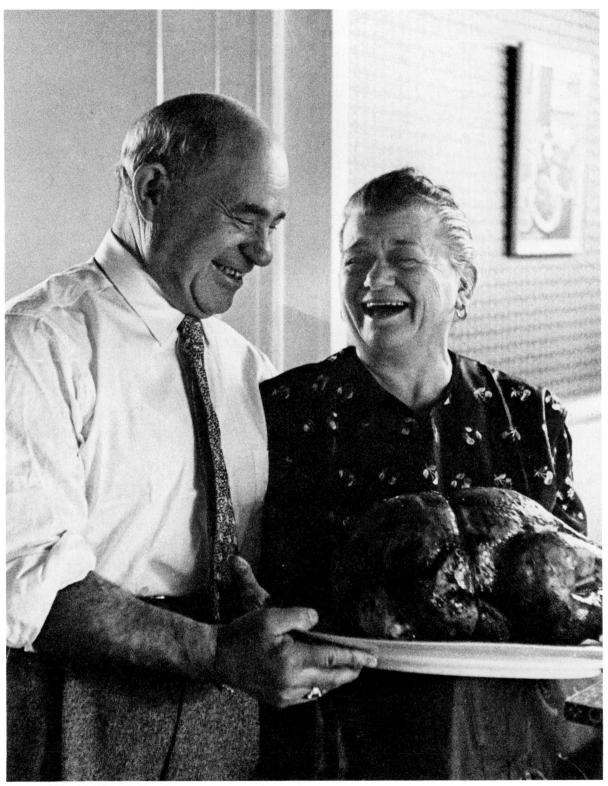

Thanksgiving Turkey, 1960.
Nikon F 35 mm, with 50 mm lens.
Tri-X film exposed 1/60 sec. at f/2.8.

116

Avocado, 1967.
Deardorff 8″ × 10″, with Ektar 30 cm lens.
Ektachrome Type B film exposed 2 sec. at *f*/11.
(Black-and-white conversion shown.)

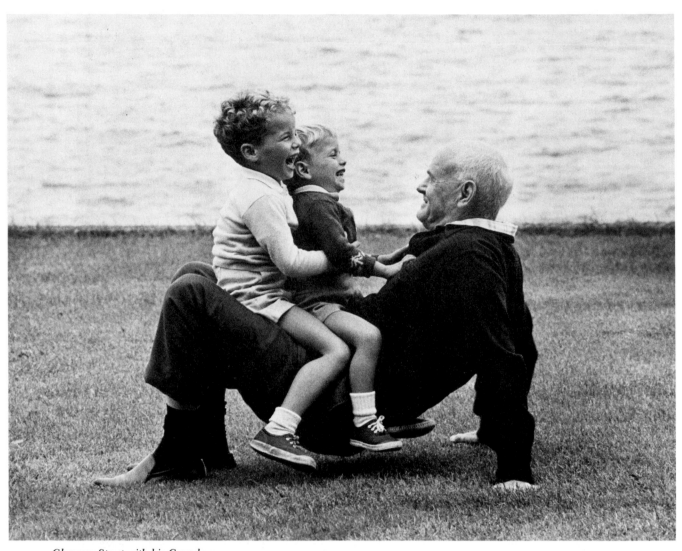

Clarence Streit with his Grandsons,
Long Island, New York, 1968.
Leica M3 35 mm, with Summicron 50 mm lens.
Tri-X film exposed 1/250 sec. at f/8.

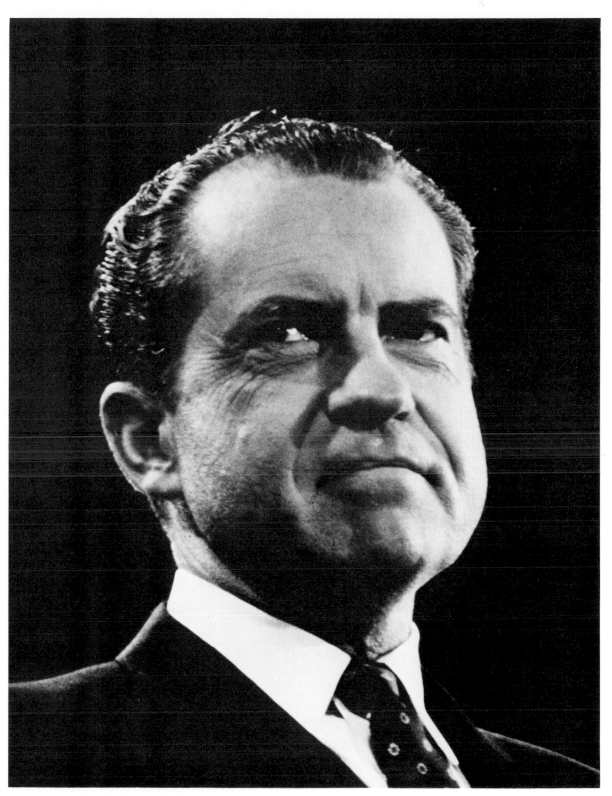

President Richard M. Nixon, 1970.
Nikon F 35 mm, with 200 mm lens.
High-Speed Ektachrome film exposed 1/250 sec. at f/4.
(Black-and-white conversion shown.)

119

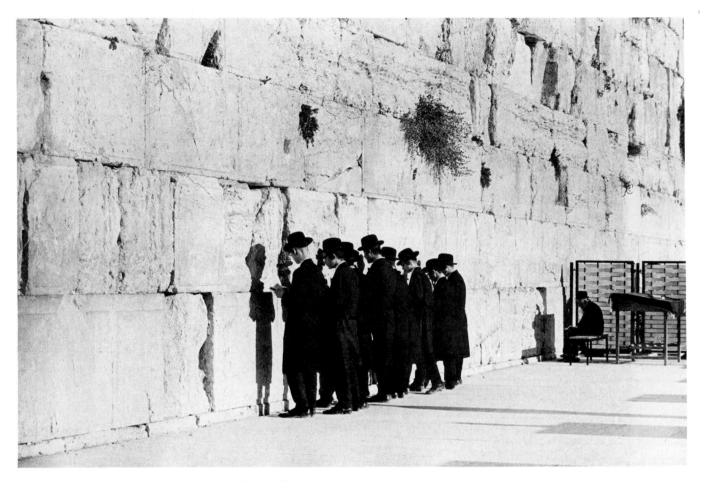

Praying at the Temple Wall, Jerusalem, 1971.
Nikon F 35 mm, with 105 mm lens.
Kodachrome film exposed 1/125 sec. at f/8.
(Black-and-white conversion shown.)

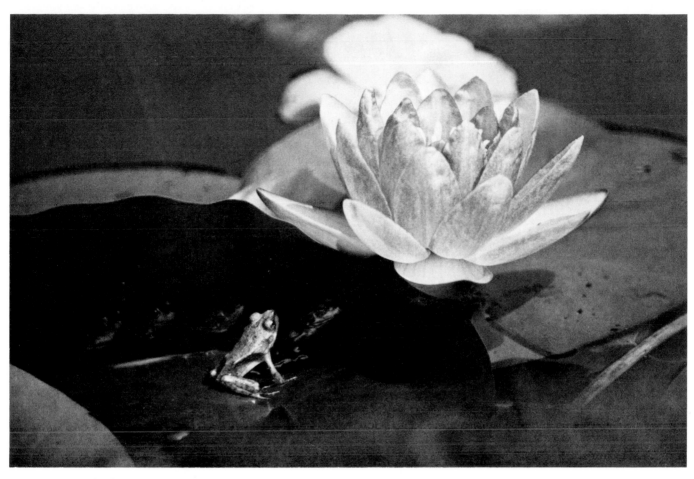

Frogs in the Lily Pond, 1972.
Nikon F 35 mm, with 300 mm lens.
Ektachrome film exposed 1/500 sec. at f/5.6.
(Black-and-white conversion shown.)

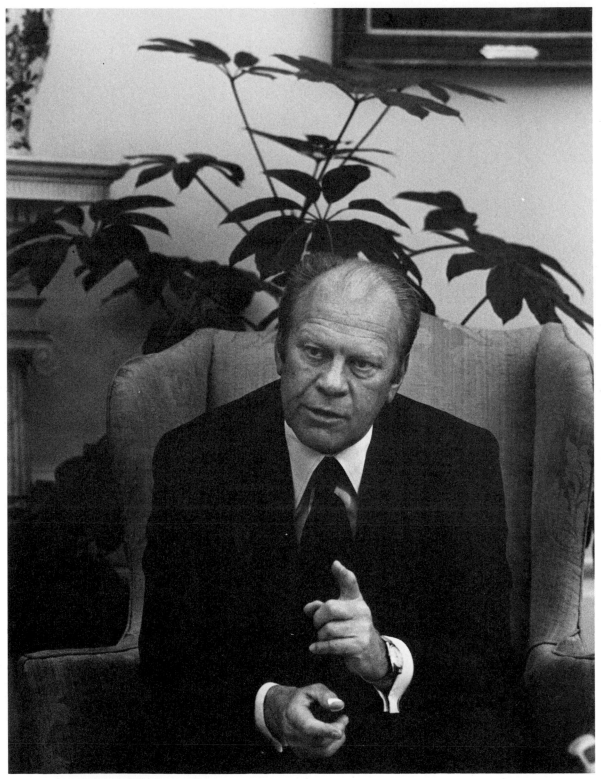

President Gerald B. Ford, 1976.
Nikon F 35 mm, with 105 mm lens.
High-Speed Ektachrome film exposed 1/125 sec. at f/2.5.
(Black-and-white conversion shown.)

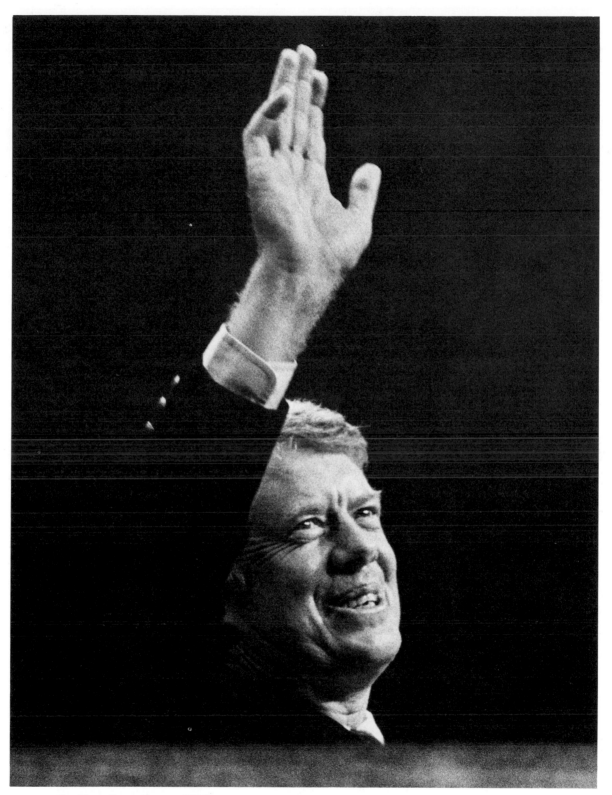

President Jimmy Carter, 1976.
Nikon F 35 mm, with 300 mm lens.
Tri-X film exposed 1/500 sec. at f/4.5.

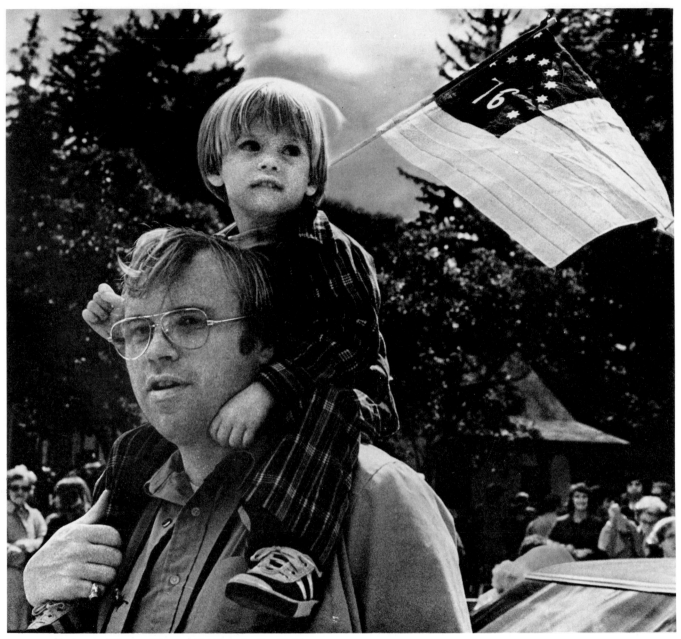

Father and Son at Bicentennial Parade, Stockbridge,
Massachusetts, 1976.
Nikon F 35 mm, with 50 mm lens.
Ektachrome film exposed 1/250 sec. at *f*/8. (Black-and-white
conversion shown.)

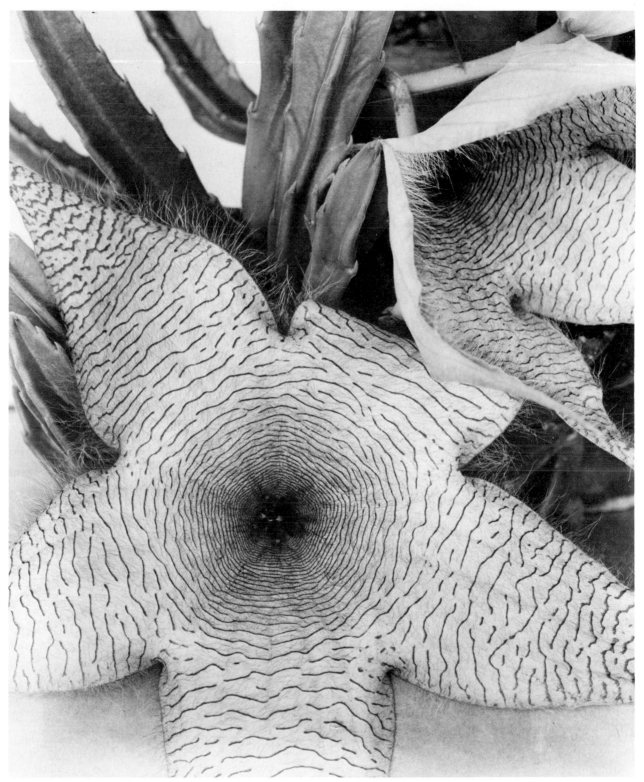

Stapelia, 1977.
Deardorff 8″ × 10″, with Ektar 30 cm lens.
Panatomic-X film exposed 1/2 sec. at f/22.

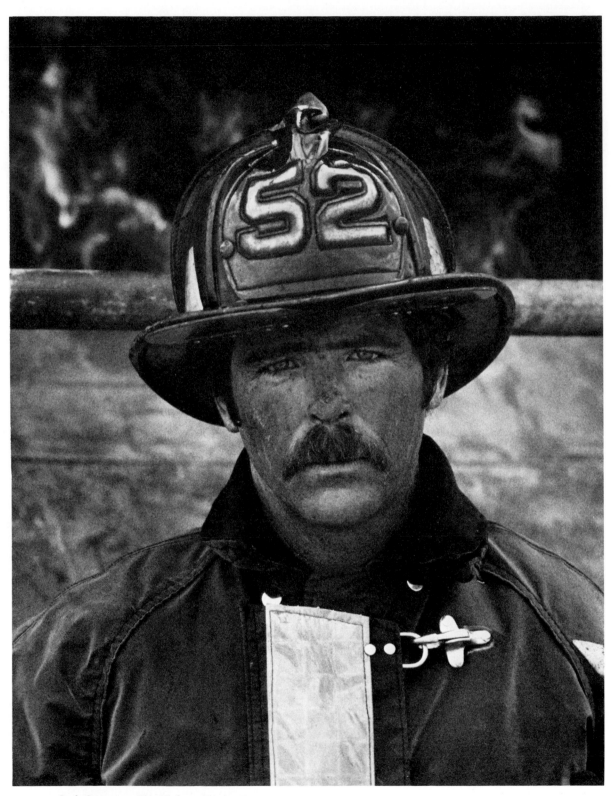

Jack Canavan, Fire Fighter, Engine Company 52, Boston, Massachusetts, 1978.
Nikon FM 35 mm, with 105 mm lens.
Ektachrome film exposed 1/125 sec. at *f*/5.6.
(Black-and-white conversion shown.)

One-Man Shows
of Pictures by Arthur Rothstein

1956 — George Eastman House, Rochester, New York

1960 — Biblioteca Communale, Milan, Italy

1963 — Smithsonian Institution, Washington, District of Columbia

1964 — World's Fair, New York, New York

1966 — Photokina, Cologne, West Germany

1967 — "Look at Us," Kodak Exhibit Center, New York, New York

1972 — Michigan State University, Lansing, Michigan

1973 — University of Massachusetts, Boston, Massachusetts

1974 — United States Information Service, traveling show sent to 60 countries

1975 — Washington Photo Gallery, Washington, District of Columbia

1976 — "My Land, My People," International Museum of Photography, Rochester, New York

1977 — Brigham Young University, Salt Lake City, Utah

1978 — Prakapas Gallery, New York, New York

1978 — *Parade*, Buffalo, New York

1979 — Western Heritage Museum, Omaha, Nebraska

1979 — Empire State Plaza, Albany, New York

1979 — Fine Arts Museum of the South, Mobile, Alabama

Group Shows
That Included Photographs
by Arthur Rothstein

1937 — Corcoran Museum of Art, Washington, District of Columbia

1938 — First International Photographic Exposition, New York, New York

1940 — International Exhibition of Modern Art, Paris, France

1945 — Town Hall, New Delhi, India

1949 — "The Exact Instant," Museum of Modern Art, New York, New York

1962 — "The Bitter Years, 1935-41," Museum of Modern Art, New York, New York

1963 — Metropolitan Museum of Art, New York, New York

1963 — "Art in Dance," Museum of Art, Eugene, Oregon

1964 — Museum of Fine Arts, Springfield, Massachusetts

1966 — Colorado Photographic Arts Center, Denver, Colorado

1968 — Newport Harbor Art Museum, Balboa, California

1971 — Royal Photographic Society, London, England

1971 — University of Nairobi, Kenya

1971 — Neikrug Gallery, New York, New York

1971 — "The Artist as Adversary," Museum of Modern Art, New York, New York

1973 — Colorado Photographic Arts Center, Denver, Colorado

1973 — Victoria and Albert Museum, London, England

1973 — Library of Congress, Washington, District of Columbia

1974 — Soho Photo Gallery, New York, New York

1974 — Neikrug Gallery, New York, New York

1975 — Library of Congress, Washington, District of Columbia

1976 — Witkin Gallery, New York, New York

1976 — Macalester College, Saint Paul, Minnesota

1977 — "New Deal Art," Delaware Art Museum, Wilmington, Delaware

1977 — Sheldon Art Gallery, Lincoln, Nebraska

1977 — Museum of Art, Santa Barbara, California

1978 — New York State Gallery Association, Albany, New York

1978 — "Photo League," International Center of Photography, New York, New York

Index